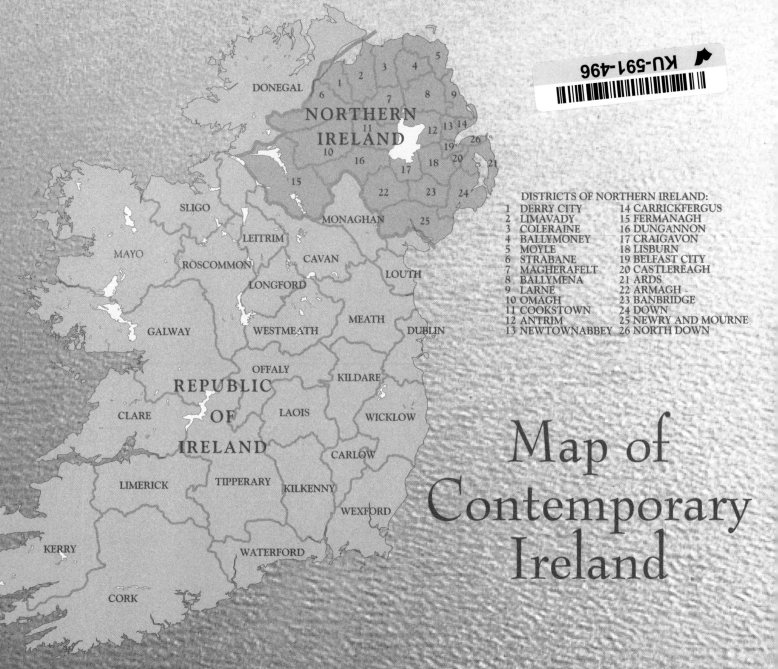

Map of Contemporary Ireland

DONEGAL

NORTHERN IRELAND

REPUBLIC OF IRELAND

SLIGO
MAYO
LEITRIM
ROSCOMMON
CAVAN
LONGFORD
MONAGHAN
LOUTH
GALWAY
WESTMEATH
MEATH
DUBLIN
OFFALY
KILDARE
CLARE
LAOIS
WICKLOW
CARLOW
LIMERICK
TIPPERARY
KILKENNY
WEXFORD
KERRY
WATERFORD
CORK

DISTRICTS OF NORTHERN IRELAND:

1	DERRY CITY	14	CARRICKFERGUS
2	LIMAVADY	15	FERMANAGH
3	COLERAINE	16	DUNGANNON
4	BALLYMONEY	17	CRAIGAVON
5	MOYLE	18	LISBURN
6	STRABANE	19	BELFAST CITY
7	MAGHERAFELT	20	CASTLEREAGH
8	BALLYMENA	21	ARDS
9	LARNE	22	ARMAGH
10	OMAGH	23	BANBRIDGE
11	COOKSTOWN	24	DOWN
12	ANTRIM	25	NEWRY AND MOURNE
13	NEWTOWNABBEY	26	NORTH DOWN

IRISH LANDSCAPES

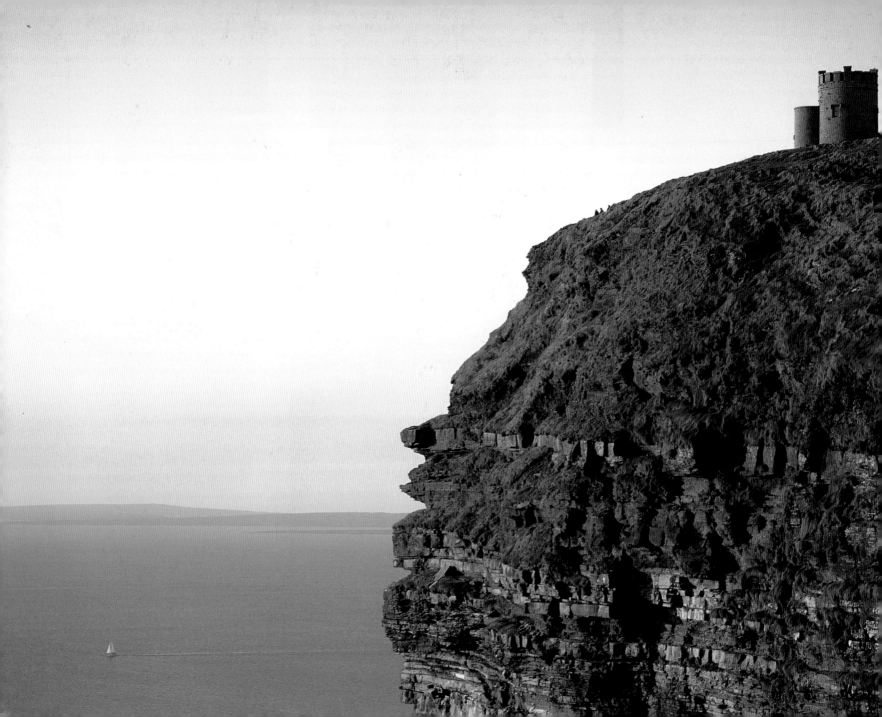

ANCIENT IRISH LANDSCAPES

IAIN ZACZEK

PHOTOGRAPHY BY
DAVID LYONS

GILL & MACMILLAN

Published in Ireland by
Gill & Macmillan Ltd
Goldenbridge
Dublin 8
with associated companies throughout the world

First published in Great Britain in 1998 by
Collins and Brown Limited

Printed and bound in Italy. First edition.

2 4 6 8 10 9 7 5 3 1

ISBN 0-7171-2727-3

Conceived, edited and designed by
Collins & Brown Limited

Editorial Director Sarah Hoggett
Art Director Roger Bristow
Editor Lisa Balkwill
Designer Bill Mason

Map by Andrew Farmer

JACKET ILLUSTRATIONS:

FRONT: Co. Antrim, Glenaan, Neolithic court
cairn of St Ossian's grave.

BACK: Co. Kerry, Dingle Peninsula, beehive hut.

HALF TITLE: Co. Wicklow, Glendalough, St Kevin's Church.

TITLE: Co. Clare, the Cliffs of Moher.

ACKNOWLEDGMENTS

David Lyons – My thanks to:
The numerous people I have encountered over the years whilst photographing in the temples, tomb sites and farm fields throughout Ireland for their kindness, patience and conversation.
 I am particularly indebted to Aida Monsell and Ronan Whelan at the Department of Arts, Culture and the Gaeltacht, Dublin, for helping to open some doors, and to Maria O'Connell for applying a little Chicago-style efficiency to a stubborn photographer.

Thanks also to my family in Bushmills for putting up with me and providing 'base camp' once again, and my gratitude to Duncan Harrison of Positive Image, Leeds, who has processed my films for many years with dependable care.
 And to quote the blessing of the man on the banks of the Shannon,
 '*May they be in Heaven a week before the Devil knows they're dead.*'

CONTENTS

Map of Ancient Ireland

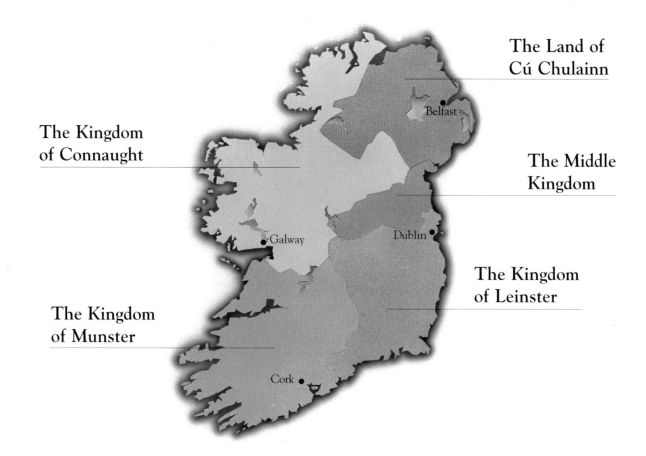

The Land of
Cú Chulainn

Belfast

The Kingdom
of Connaught

The Middle
Kingdom

Galway

Dublin

The Kingdom
of Leinster

The Kingdom
of Munster

Cork

INTRODUCTION

ANY TRAVELLER IN Ireland will swiftly come to appreciate the rich diversity of the landscape. Around the Leinster plains and the foothills of the Wicklow mountains, there are stretches of rolling pastureland, as green and fertile as any farmer could wish. Along the Antrim and Donegal coastline in the north, and the Dingle peninsula in Munster, there are fine views and rocky promontories, buffeted by squalling winds and choppy seas. Inland, around Lough Erne and the banks of the winding Shannon, there are mazy clusters of lakes and wetlands, dotted with tiny, grassy islands. In the central lowlands the scene is dominated by thick tracts of peat and bogland, abounding in native wildlife. Then again, in Co. Clare, there is the strange lunar landscape of the Burren, with its bleak limestone plateau.

Each of these features presented different challenges and opportunities for Ireland's early inhabitants, helping to shape the way that they left their mark upon the landscape. At the most basic level, they determined the types of dwellings and monuments that they could build, along with the kinds of skills they could develop. It was no accident, for example, that a prehistoric axe 'factory' developed in the Antrim area, since the best seams of porcellanite rock – the preferred material for

axe-heads – were discovered on the slopes of Tievebulliagh mountain. Similarly, it is clear that beehive huts and stone cashels were much more common in the rocky districts of the south-west, than in the more fertile areas of the east and north.

The same practicalities apply to matters of defence. Because of the comparative flatness of its terrain, hillforts were less common in Ireland than in countries such as Britain. Instead, early inhabitants looked for other possibilities in the landscape. Promontory forts were popular, as the rocky Irish coastline provided a natural defence against potential attackers. Inland, there was often a tendency to make use of waterlogged sites. In loughs and in marshy areas, chieftains would fortify tiny islands or construct their own artificial islands (crannógs), surrounding them with timber palisades. This practice continued long into the Middle Ages, when castles were often situated on islands.

More important still was the question of food. The people from Ireland's most ancient site, the Mesolithic settlement at Mount Sandel, Co. Kerry (c. 7000 BC) were hunter-gatherers, surviving on a diet of salmon, eels, duck and nuts. They may have been largely nomadic, but their successors created more permanent homes. They were farmers who also raised livestock and practised the skills of pottery and weaving. Naturally, they

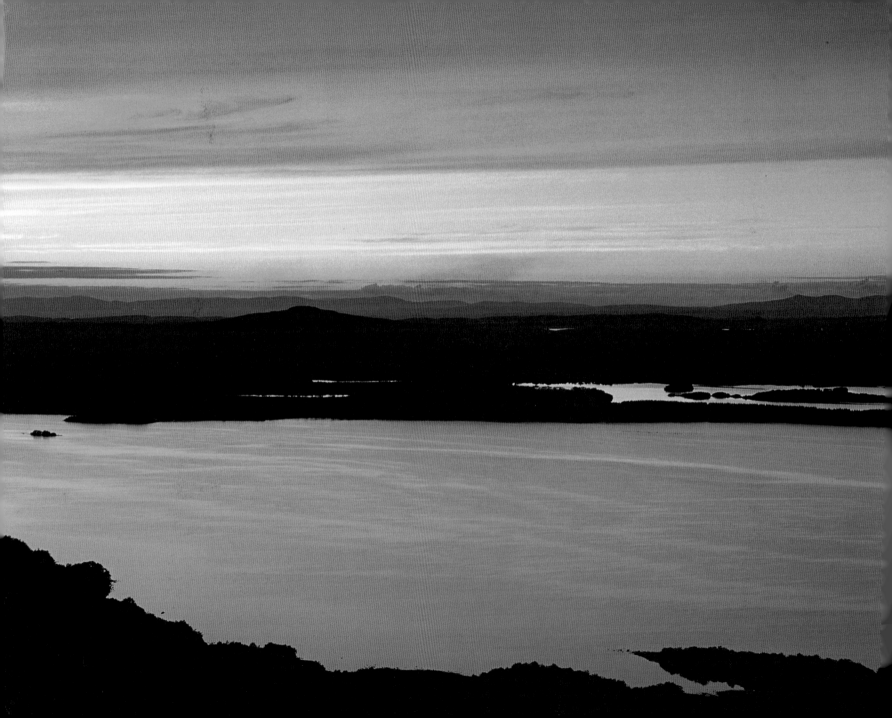

sought out the best land for their crops – usually opting for soil with good drainage and avoiding peaty and low-lying areas. Very little remains of their dwellings, which were made of perishable materials, although the Neolithic huts at Lough Gur (c. 2750 BC, p. 120–121) provide a rare exception.

These farmers also erected Ireland's great megalithic monuments, and their disposition gives the best clue to the settlements of the Neolithic population. The stone monuments date from the 4th millennium BC, with certain parts of Carrowmore (c. 3290 BC) and Newgrange (c. 3200 BC) being among the oldest. Most were communal burial places, although a few had more elaborate ritual and astronomical functions.

In essence, there were four main types of monument: court cairns, portal tombs or dolmens, passage-graves and wedge tombs. Court cairns, chamber tombs with semi-circular forecourts, were probably the earliest (see Ossian's grave, p. 53). They are restricted almost exclusively to northern areas. Portal tombs, which grace the landscape with their spectacular balancing acts, are believed to have evolved out of these. They are mainly found in the north, although there are a few examples in southern Leinster. The decorated passage-graves, the finest of all the Irish monuments, are thought to have been erected by people who came from Brittany and who landed in the river Boyne region before heading west.

By the start of the Bronze Age (c. 2000 BC) the emphasis seems to have shifted to simple wedge-tombs. The climate also became warmer during this period, leading to the spread of peat and bog over large areas of cultivated land, ruining the agricultural experiments at places like the Céide Fields (p. 24).

The Iron Age saw the arrival of the Celts in Ireland. They originated as a group of loosely-connected tribes in central Europe in around 600 BC. During the course of the La Tène period (c. 450 BC–c. 50 BC), they pushed westwards, partly through pressure from the expanding Roman empire. Their presence in Ireland may date from the 3rd century BC.

The Celts themselves viewed their early history as a series of invasions by five different races who migrated to Ireland during its historic period. These were the Partholónians, the Nemedians, the Fir Bolg, the Tuatha Dé Danaan and the Milesians. The first two groups are unidentifiable, but the Fir Bolg have been linked with the Belgae, a continental tribe of mixed Germanic and Celtic stock. They began migrating to Britain in the 1st century BC, and could have reached Ireland a century or so later. A longstanding tradition links them with the construction of some promontory forts such as Dun Aenghus (see p. 27). The Tuatha Dé Danaan were the Irish gods, led by the Dagda. According to ancient belief, it was this divine race of beings who constructed the great prehistoric mounds, to serve as palaces after they were swept from power by the Milesians. The latter have a much firmer grounding in reality and are thought to represent the ancestors of the Gaels.

LEFT: LOWERLOUGH ERNE, CO. FERMANAGH

The lake's tiny, wooded islands were a favourite haunt of hermits and holy men, such as St Molaise. His name is also linked with retreats at Inishmurray, Co.Sligo, and on the Scottish island of Arran.

Further hints about Ireland's past can be gleaned from its two ancient series of tales, the Ulster cycle and the Fionn, or Fenian, cycle. The first of these was set in the 1st century BC and its background details offer revealing insights into Iron Age society. At its heart was the rivalry between Ulster and Connaught, at a time when Tara and the Middle Kingdom had not yet risen to prominence. Instead the focus was on the northern centres of royal power, Emain Macha (now Navan Fort, p. 52) and Cruachan (now Rathcroghan). The complex remains at Navan Fort, where a series of elaborate structures were ritually destroyed by fire, suggest that 'royal' sites were more akin to shrines than strongholds.

The same cannot be said of the sites associated with the warrior heroes. The home of Cú Chulainn, the hero of the Ulster cycle, was specified as Dun Dealgan (now Dundalk). The 'dun' in this instance simply means fort, as in Dun Aenghus or Dunbeg. Surviving examples do not appear to be any more imposing than other types of fort, such as cashels or raths, but the name is used more sparingly, implying that it was reserved for places of some prestige.

The Fionn cycle of stories describes the adventures of Finn Mac Cool and his valiant knights, the Fianna. They are set in a later age, the 3rd century AD, and the social background is often blurred by subsequent Christian additions to the text. Even so, it is noticeable that Finn, very much a hero of Leinster, regards the high king at Tara as the supreme authority.

During this time Ireland's people were grouped together in *tuatha* (tribes or clans) which were ruled over by a king (*rí*).

Some kings were little more than petty chieftains, while others controlled several *tuatha*. At the top of the hierarchy, there was a high king (*ard rí*). These units were strengthened by ties of kinship which were complicated by widespread polygamy and an elaborate system of fosterage. These various measures helped to compensate for the lack of a strong, central organization, although they also gave rise to a host of inter-tribal squabbles. Worse still, they left the Irish ill-equipped to act in unison, when they were faced with their Viking and Norman foes.

Few details are known of the tribes that existed before the 5th century AD. The oldest names generally relate to animals – among them the Osraige (deer-people) and the Sordraige (boar-people) – and probably refer to their tribal gods. By the start of the early historic period, however, specific dynasties were beginning to emerge, each stemming from a powerful ancestor figure. In the pre-Viking period, the most influential of these were the Eoghanacht, the Connachta and the Uí Néill. The latter were usually dominant enough to hold the high kingship of Tara, even though this rarely brought them anything more than nominal overlordship of their rivals.

Most tribes dwelt in scattered farms and homesteads. The chief and his wealthier subjects might have lived in a crannóg (fortified lake-dwelling) or in one of the larger cashels. The remainder would have occupied the smaller ringforts or timber huts which have long since disappeared. In the rocky areas of the south-west, clocháns (beehive huts) were another option. Most of these dwellings are notoriously difficult to date. Some archaeologists assign them to the Iron Age, while others argue

that they are early medieval. The styles, it seems, changed remarkably little over the centuries and there is a surprising dearth of documentary evidence.

The most unusual feature of the Irish social system was the absence of towns and villages. This had a telling effect on the way that Christianity was introduced into the country. The organization of the Roman .Church, which was structured around the bishop and his diocese, proved unsuitable for such a diffuse community. Monasteries, on the other hand, fared much better. They became the spiritual equivalent of the *tuath*, rapidly acquiring a semi-independent character. Their buildings did not, as yet, follow the well-ordered continental model. Rather, they resembled a haphazard settlement, as the remains at Glendalough (p. 156) confirm. Even so, religious houses were carefully sited. Abbots ensured that communications were good and that the land was suitable for livestock or crops. In addition, monasteries were invariably close to the stronghold of a powerful secular lord, whether for reasons of patronage or protection. Accordingly, most of the major foundations were located in central or eastern Ireland.

In contrast, early Christian hermits chose to live in remote, isolated spots. They did so in a spirit of self-sacrifice, for this was a period when any man who left his tribe was deprived of both his legal and social identity. Some idea of this spartan existence can be gained from the remains at Skellig Michael and the Gallarus oratory (p. 129), although many of the sites were later turned into churches, as at Dysert O'Dea. Others were looted and abandoned after the Norsemen began to arrive.

The monasteries, meanwhile, became important artistic centres. Magnificent illuminated manuscripts were produced in the monastic workshops, while the altars gleamed with displays of ornate liturgical vessels and reliquaries. Sadly for the monks, these riches attracted the attention of Viking marauders and many of them ended up as booty, carried back to the longships. Only the heavy stone crosses, which adorned the monastery precincts, were spared this indignity.

The first Viking raid on Irish soil took place in 795. At first, these attacks were small-scale affairs carried out by minor warlords. Then, as the lack of serious resistance became evident, the violence escalated. By the 830s, the Norsemen were despatching huge floating fortresses which they moored in rivers like the Boyne and Liffey and then used as departure points for inland raids. Armagh, Kildare and Glendalough were all pillaged, before the Norsemen turned their attention to the creation of permanent settlements. Many of Ireland's major cities – Dublin, Cork, and Limerick among them – were founded in this way. The Irish response to the invasion was muted. Inter-tribal warfare continued unabated and, after a time, the Viking settlements became participants in these struggles. This state of affairs continued until the end of the 10th century when Brian Boru finally managed to mount a serious challenge to the invaders. His victory at Clontarf (1014) is usually cited as the closing episode in Ireland's Viking saga.

More than any of his predecessors, Brian managed to inject a real sense of power and authority into the role of high king. Much of this work was soon undone, as the provincial rulers

returned to their old animosities. This reached a dangerous pitch in the 12th century, when the Connaught-born high king, Turlough O'Connor, tried to bolster his position by dividing up Meath and Munster. His son, Rory O'Connor, continued in the same vein by attacking King Dermot of Leinster and expelling him from his castle. Dermot swiftly fled to Henry II of England, appealing to him for help. Henry, who had already secured papal backing for an invasion, helped Dermot to return to

BELOW: MUIREDACH'S CROSS, MONASTERBOICE, CO. LOUTH

The carvings on some Celtic crosses mirror the grotesque decoration
found in Irish manuscripts. Here, two cats devour a bird and frog.

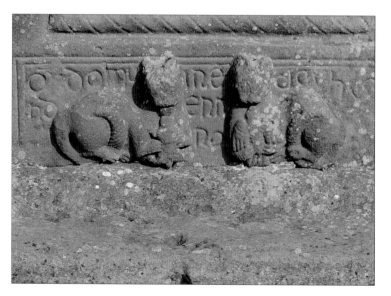

Ireland with a force of men, led by Strongbow, the Earl of Pembroke. Victory followed immediately and, throughout the 1170s, waves of Norman adventurers sailed across to Ireland, eager to make their fortunes. Alarmed at their success, Henry reserved a strip of land on the eastern seabord – soon to become known as the English Pale – while allowing his barons to take what they could of the remainder. This they did with brutal efficiency. In 1183, Rory O'Connor gave up the struggle and retired to the Abbey of Cong. He was the last to hold the post of high king and, with his passing, Ireland's most important link with the past was broken.

In ancient times, Ireland had stood at the very edge of the known world. The people who journeyed there were pioneers, whether they were warriors seeking out new lands or hermits looking for a peaceful haven. The signs of their endeavours can still be found, half-hidden in the tucks and folds of the landscape. From the majestic remains of prehistoric tombs and ringforts to the modest shells of beehive huts and farmsteads, the memories of a distant past live on, conjured up by the beautiful photographs on these pages.

The five chapters in this book reflect the *cóiceda* or 'fifths', the independent provinces recognized by the ancient Celts. These were Connaught, Ulster (the land of Cú Chulainn), the Middle Kingdom of Meath, Munster and Leinster.

RIGHT: NORTH CROSS, AHENNY, CO. TIPPERARY

The design of this cross was probably inspired by Celtic metalwork of
the period. The five studs may be the equivalents of the original rivets.

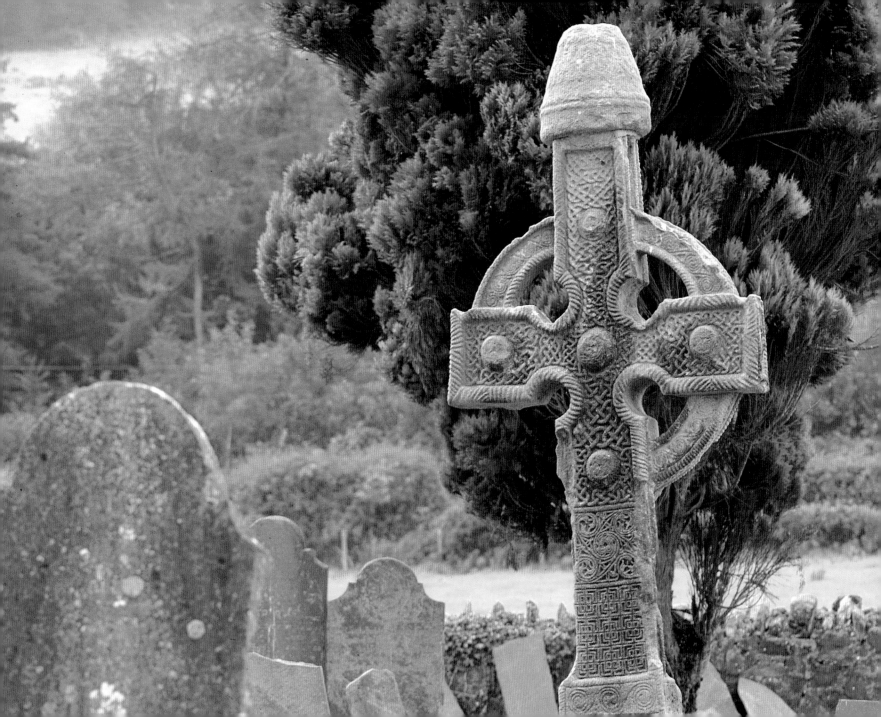

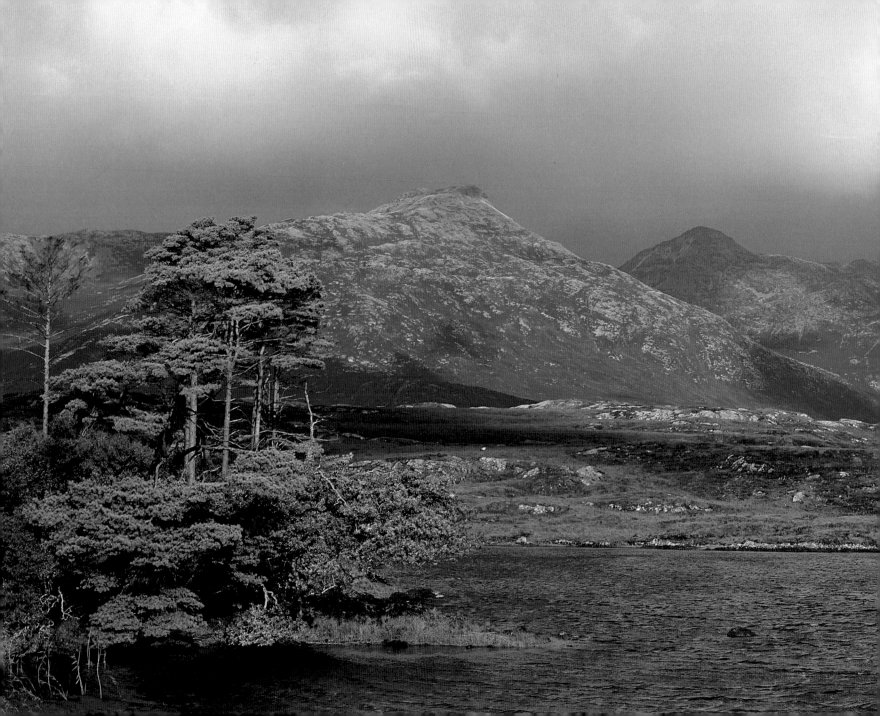

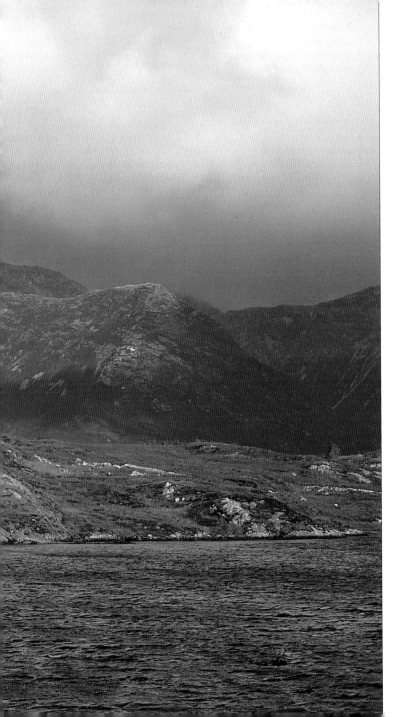

THE KINGDOM OF
CONNAUGHT

CONNAUGHT IS named after Conn Cétchathach (Conn of the Hundred Battles), one of the ancient high kings. He is supposed to have lived during the 2nd century AD and was the founder of a dynasty; his descendants became known as the Connachta. In 137 he participated in the battle of Magh Léana, a conflict that pitted him against Eoghan of Munster and is said to have led to the division of Ireland into two kingdoms, the north and the south.

The original province of Connaught played a major part in the legends of the Ulster cycle, the ancient tales from Ireland's heroic age. These stories are thought to be set in the 1st century BC, but they were transmitted orally for many hundreds of years and became modified in the process.

LEFT: DERRYCLARE LOUGH, CONNEMARA, CO. GALWAY

Connemara is sometimes thought to take its name from Conmac, the son of Maeve and Fergus. Maeve was the queen of Connaught and Fergus was an exiled Ulster warrior.

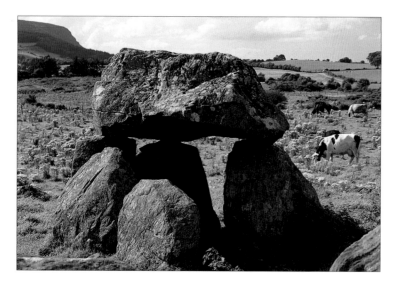

ABOVE: CARROWMORE, CO. SLIGO

Grave 7 is one of the best preserved graves at the megalithic cemetary of Carrowmore. Dating back to c. 3290 BC, it stands at the centre of a circle of 31 stones and contains the remains of four cremation burials between its uprights.

The chief story in the Ulster cycle was the epic *Táin Bó Cuailnge* (*Cattle Raid of Cooley*). This described a bitter war that was waged between Ulster and Connaught over the possession of an enchanted bull. During this campaign Connaught's forces were led by Medb and her consort King Ailill against the Ulster warrior Cú Chulainn (see p. 47). Medb was frequently anglicized as Maeve and in this form she has been linked with a

number of prehistoric monuments, most notably the burial mound near Carrowmore (see left and pp. 22–23).

Maeve was originally a goddess of war and sovereignty, and in this latter guise was involved in ritual matings with kings at the sacred sites of Tara and Cruachan, Connaught's ancient capital now identified as Rathcroghan (Rath of Cruachan) in County Roscommon. Along with Newgrange and Tailte, Cruachan was famed as one of the three sacred cemeteries of prehistoric times; it was also thought to possess a hidden gateway to the Otherworld.

The fact that Maeve was linked with both Tara and Cruachan tallies well with early historic developments. It is widely believed that the Connachta were the ancestors of Niall Noígiallach (Niall of the Nine Hostages), one of the first kings of Tara, and his descendants the Uí Néill, the dynasty which came to dominate most of northern Ireland. It seems that they rose to prominence in the 5th century, sweeping aside the power of the Ulster people and seizing Tara from the tribes of Leinster. This appears to have coincided with a time when the Connachta were pushing eastwards, out of their traditional homeland. The legend that Niall was the youngest son of a Connaught king and a British slave-girl tends to support this theory, for his status would have forced him to carve out new territories for himself.

As time passed, the Connachta divided into three main branches. These were the Uí Maine, who controlled the area to the south of Lough Corrib; the Uí Briúin, who settled in the neighbouring land; and the Uí Fiachrach, who were based in

northern Mayo. The kingship tended to rotate between these last two groups, with neither dynasty managing to hold onto power for very long.

Notable leaders of the Uí Briúin included Aed (d. 577), who fought at the battle of Cúil Dreimne, and Rogallach (d. 649), who seized the kingship after the battle of Canbo (622). Among the Uí Fiachrach, meanwhile, the most powerful ruler appears to have been Guaire (d. 663), who managed to beat off challenges to his throne in 653 and 654.

During the Christian period, the key figure in Connaught was St Enda (d. *c.* 530) who trained at St Ninian's monastery at Whithorn, Galloway. His chief foundation was at Inishmore on the Aran Islands, where the monastic school produced distinguished pupils such as St Ciaran, the founder of the monastery of Clonmacnois.

In the secular sphere, the Connachta were eventually superseded by the O'Connors. Their leading figure was Turlough O'Connor, who became king of the province in 1106 and high king in 1119. He embarked upon a non-stop series of campaigns, resulting in Munster's division into Thomond and Desmond, with one section going to the O'Briens and the other to the Mac

Carthys. In Meath he pursued a similar policy, dividing the kingdom into three parts and stoking up the traditional rivalry between it and Leinster. O'Connor was scarcely less active in matters of religion. He made generous donations to Cong, Co. Mayo, commissioning its famous cross, and raised the profile of the church at Tuam in Co. Galway, to such an extent that it was made an archbishopric at the Synod of Kells (1152).

Unfortunately for the province, Turlough O'Connor's successor did not inherit his abilities and the divisions which had been created offered a tempting opportunity for the Normans. Rory O'Connor proved to be the country's last high king, eventually retiring to Cong in 1183. By this time the Anglo-Norman invasion was in full flow, as waves of adventurers crossed the Irish Sea to make their fortunes. Connaught, however, did not feel the brunt of this until after the 1230s, when the de Burgos became the dominant lords in the area.

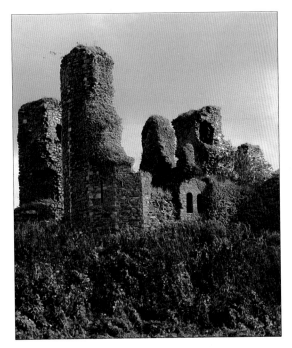

LEFT: GREENCASTLE, CO. DONEGAL

Also known as Northburgh or Newcastle, Greencastle was built by Richard de Burgo, the 'Red' Earl of Ulster, in 1305. It fell to Edward Bruce in 1316, but was recaptured by de Burgo two years later.

CARVED FACE, CARNDONAGH, CO. DONEGAL

Left: EARLY MISSIONARIES used to Christianize the prehistoric stones they found by carving a simple cross on them. Gradually they became more ambitious, hiring artists to sculpt complex Biblical scenes on their Celtic crosses. The carvings at Carndonagh mark a very early stage in this process, as they were among the first to feature human figures.

CARVED 'STATION' PILLAR, GLENCOLUMBKILLE, CO. DONEGAL

Right: THE VALLEY of Glencolumbkille takes its name from St Columba, who is said to have confronted a demon here. In commemoration of this, a special *turas*, 'pilgrimage', is held on the saint's feast day. This entails sending worshippers on a 4.8-kilometre (3-mile) trek to visit 15 different 'stations', similar to the Christian Stations of the Cross. Most of these are either prehistoric sites or rock formations, such as Columcille's Chair. The route to the different stations is marked by a series of early cross-slabs or pillars.

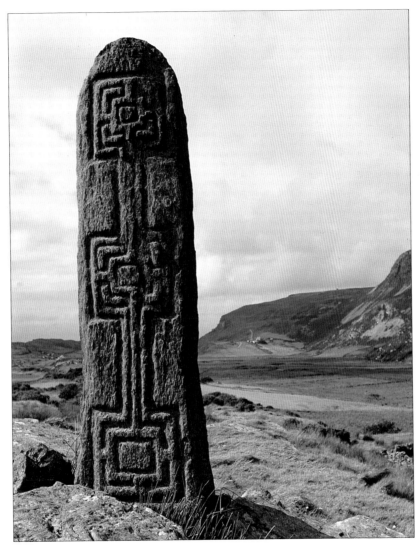

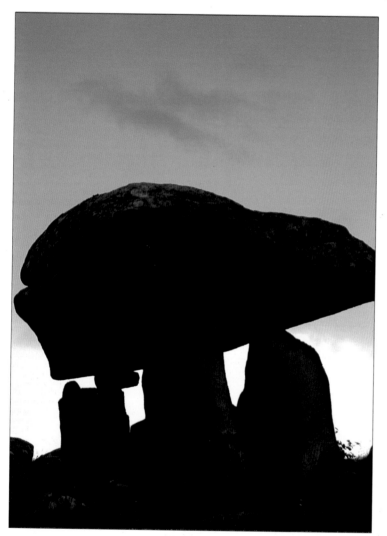

KILCLOONEY PORTAL DOLMENS, CO. DONEGAL

NOT FAR FROM ARDARA, stands a pair of portal dolmens,
popularly known as the beds of Diarmaid and Gráinne.
They were the subject of one of the most famous stories in Irish
mythology. Gráinne was due to marry Finn Mac Cool, the
warrior hero of Irish legend, but shortly after the betrothal feast
she eloped with Diarmaid, a leading warrior under Finn's
command. For 16 years, Finn pursued the couple relentlessly,
forcing them to take shelter in a series of forests, caves and
remote hiding-places before they were finally rescued by
Oenghus, the god of love.

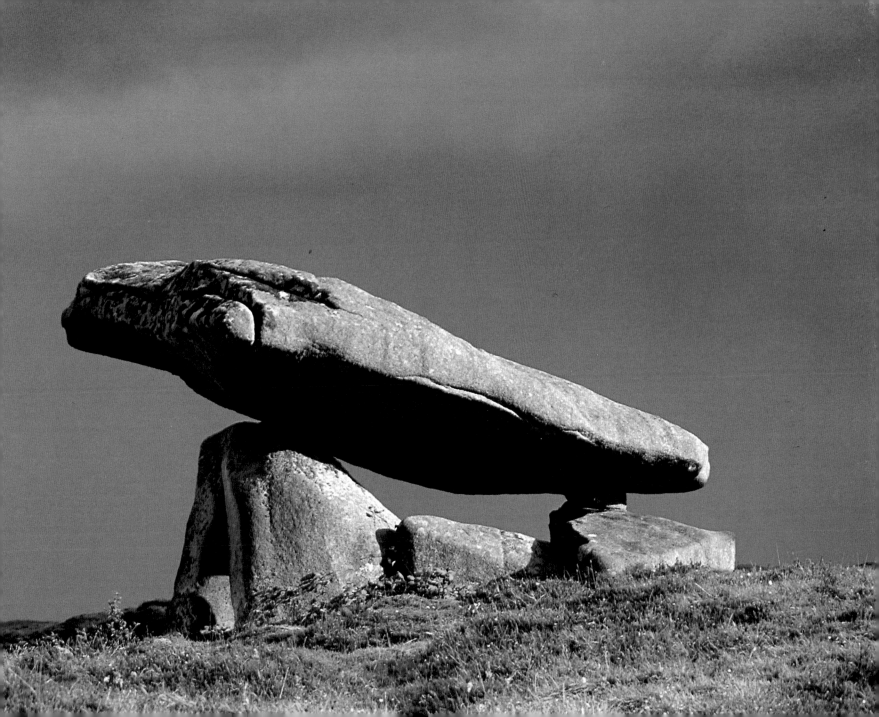

CARROWMORE, CO. SLIGO

Right: THE MEGALITHIC CEMETERY at Carrowmore may once have been the largest in Europe. A century ago, more than a hundred graves were still in existence here, but this number has now dwindled alarmingly. One of the best-preserved examples is grave 7, in the foreground, parts of which date back to *c.* 3290 BC. Consisting of a polygonal chamber, it is surrounded by a ring of boulders. In the background is a huge cairn, traditionally known as Maeve's Lump. This commemorates the supernatural queen of Connaught, who waged war against Cú Chulainn in the *Cattle Raid of Cooley*.

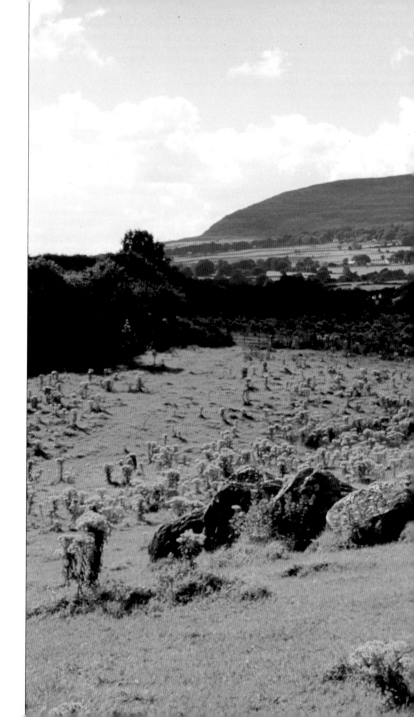

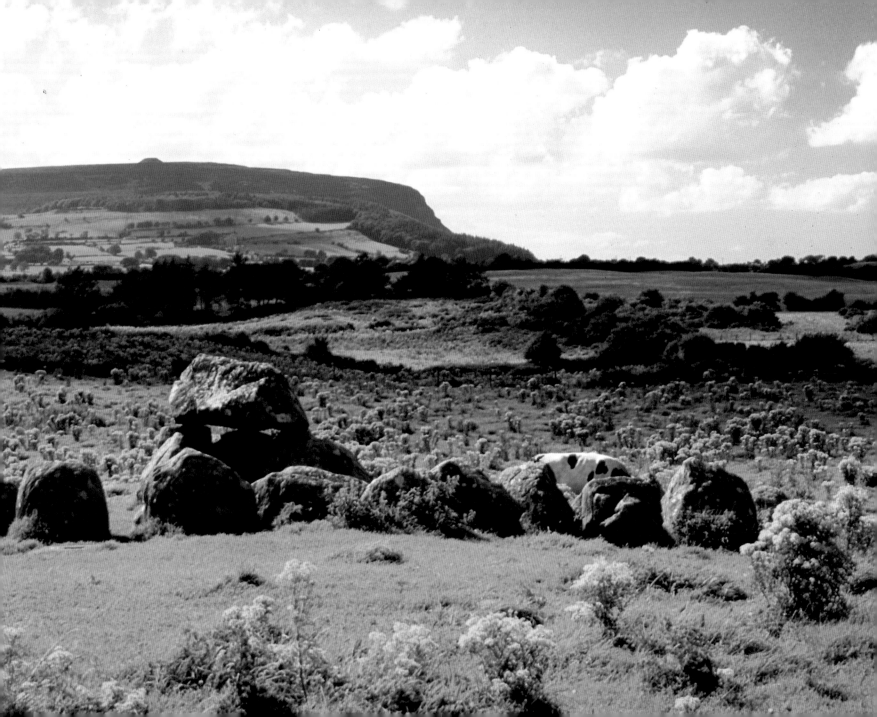

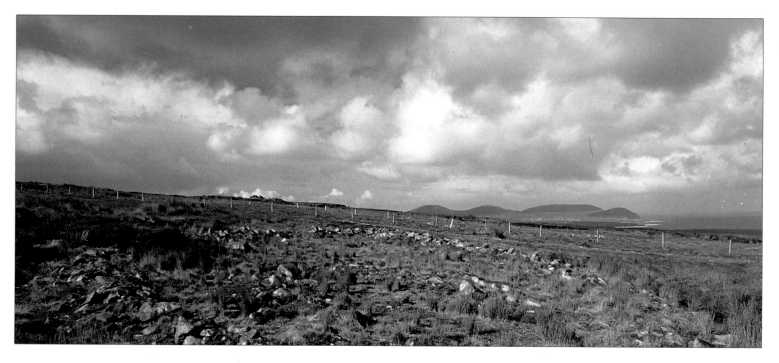

CÉIDE FIELDS, CO. MAYO

Above: HIDDEN UNDER A bleak stretch of moorland, close to the
north Mayo coastline, are the remains of Europe's largest-known prehistoric
farming settlement. Apparently planned as a single enterprise and run on a
communal basis, it is criss-crossed by a huge network of stone-walled
enclosures. The settlement survived until a gradual change in climate
buried the fields beneath a layer of bogland.

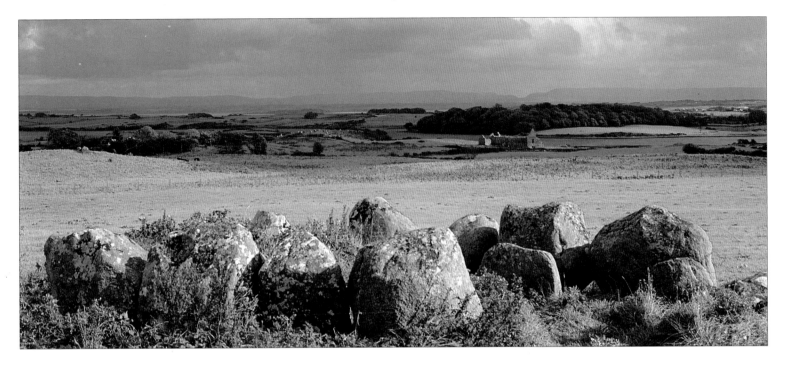

RATHFRAN WEDGE-TOMB, CO. MAYO

Above: WEDGE-SHAPED GALLERY GRAVES are the most common
form of megalithic monument in Ireland. Almost 400 examples are
known, most of them concentrated in the west of the country.
They consist of long, rectangular chambers, which are wider and
higher at the front. Usually these chambers are covered with
capstones, although these are missing at Rathfran.

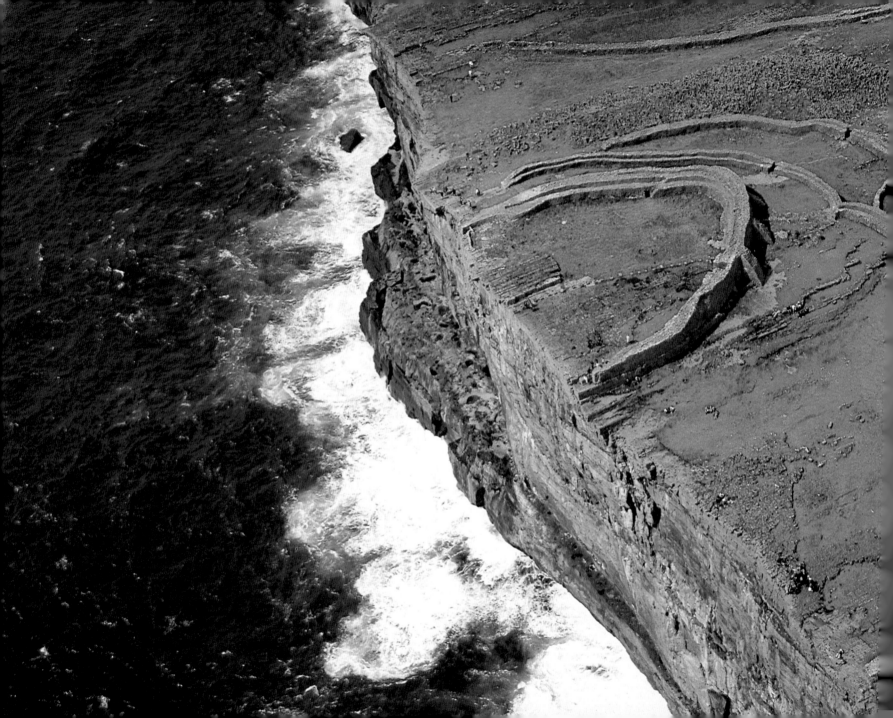

Dun Aenghus, Aran Islands, Co. Galway

Left: WITH ITS SPECTACULAR position, crowning the
summit of a vertical cliff-face, Dun Aenghus is the finest
of the Irish promontory forts. Its walls are 4 metres
(12 feet) thick in places, and access to the inner
enclosure could only be gained through three narrow
gaps. The most formidable aspect of its defence,
however, was the *chevaux-de-frise*, 'Friesian horses',
a ring of tightly packed stone spikes hugging the curves
of the second wall. Legend ascribes the building of Dun
Aenghus to the Firbolg, a mythical people sometimes
associated with the Belgae, distant ancestors of the
Belgians. Archaeological finds within the fort suggest
that it may date back to the Celtic Iron Age.

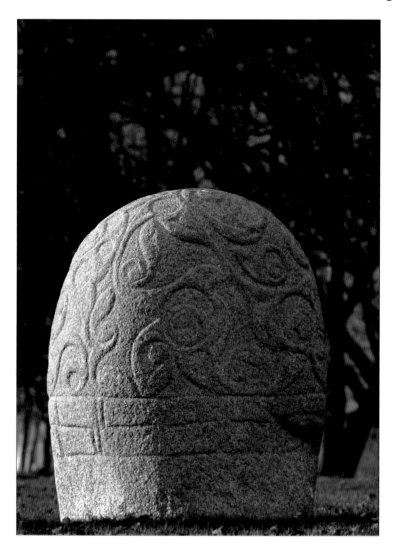

THE TUROE STONE, CO. GALWAY

Left: THIS DOMED GRANITE monolith, is covered in a series of
flowing, tendril patterns, which link it with the art of the
prehistoric La Tène period. Similar motifs can be found on the
metalwork produced by the ancient Celts. The stone is situated
near a ringfort and burial site, but its elaborate design and
phallic shape suggest that it served a ritual purpose.

FINN MAC COOL'S FINGER STONE, EASKY, CO. SLIGO

Right: ALSO KNOWN SIMPLY as the Split Rock, this is one of a
number of monuments named after the legendary hero, Finn
Mac Cool. He was the Irish equivalent of King Arthur, the
leader of a band of valiant knights called the Fianna. According
to legend, Finn could foresee the future when he sucked his
thumb, a power which he gained after burning it on the magical
Salmon of Knowledge.

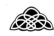

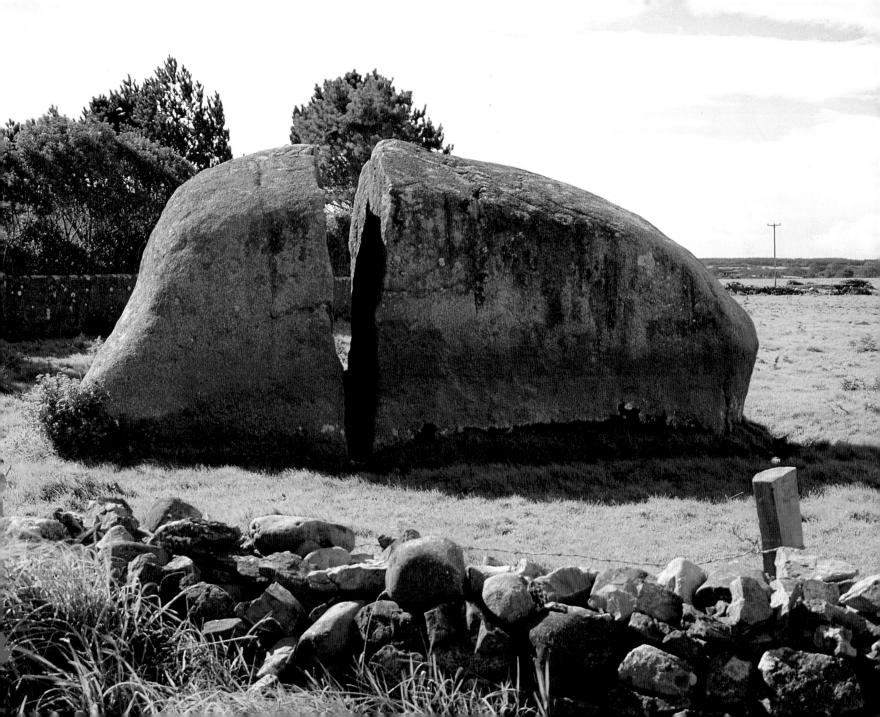

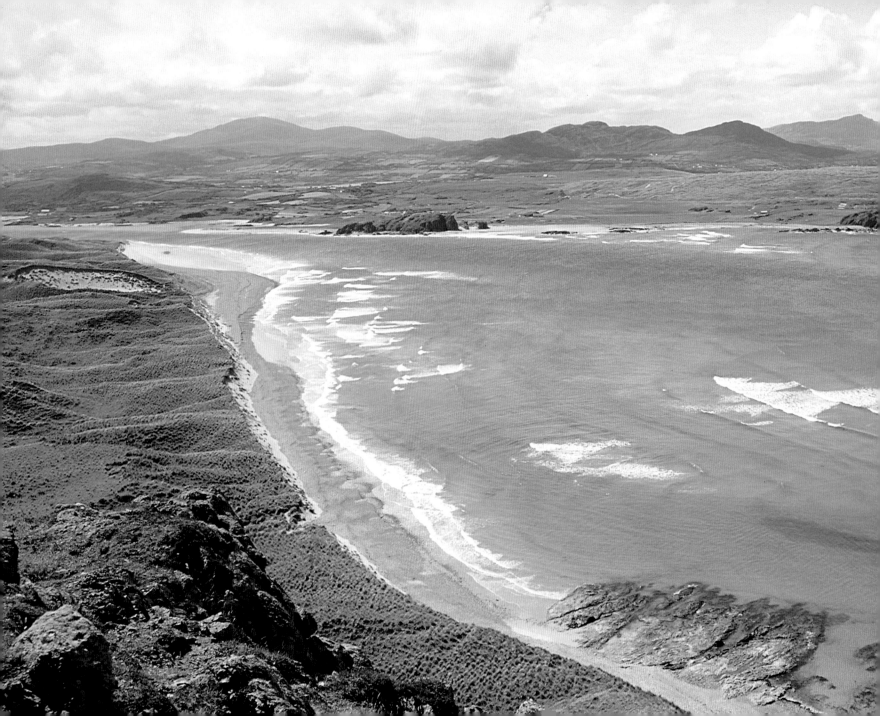

Inishowen Peninsula, Co. Donegal

Left: THE WAVES ROLL IN near Malin Head, the most northerly point of Ireland on the Inishowen Peninsula. This stretch of coastline boasts several ancient monuments, most notably the chamber tombs at Malin and Carrowmore, and the promontory forts of Dunargus and Dungolgan. The chief attraction on the peninsula, however, is the ivy-clad ruin of Greencastle (see p. 17). This was erected in 1305 by Richard de Burgo, the 'Red' Earl of Ulster, in the hope that it would cement Norman power in the region. These ambitions were short-lived, as the castle was seized by Edward Bruce, the brother of Robert Bruce, just a decade later.

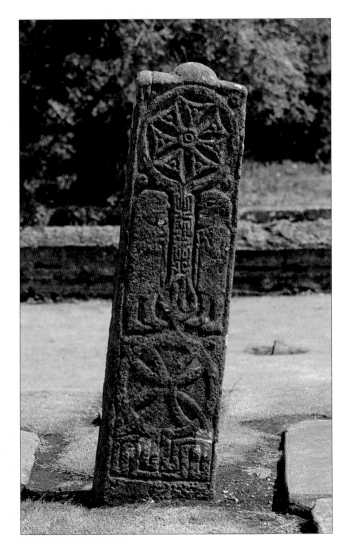

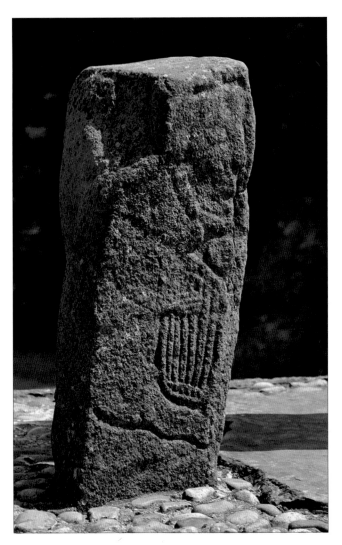

CHRISTIAN PILLAR-STONES, CARNDONAGH, CO. DONEGAL

BEFORE THE TRADITIONAL design of the Celtic cross evolved,
Irish artists used to carve religious scenes onto shaped stone
slabs. The examples at Carndonagh are among the earliest,
perhaps dating back as far as the 7th century. One figure
(detail, right), possibly a pilgrim, carries a bell, book and staff.
Another (left) holds a harp and has been tentatively identified
as King David, the author of the Psalms. The large 'marigold'
cross (far left) is thought to be a stylized version of a
flabellum, a liturgical fan.

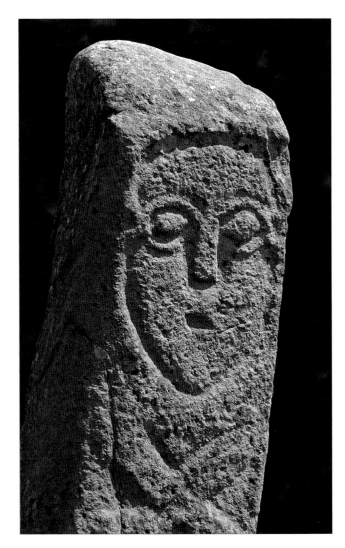

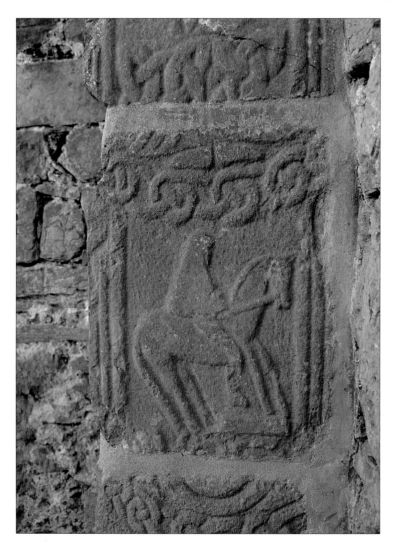

INISHMORE, ARAN ISLANDS, CO. GALWAY

Right: MANY IRISH MONKS desired nothing more than to seek out some remote and inaccessible spot, where they could devote themselves to a life of manual labour and prayer. The Aran Islands were a favourite choice and Inishmore – the largest of the islands – is covered in early Christian sites. The holiest of these was Tighlagheany, 'Enda's Household', dedicated to the 5th–6th century saint, who was granted the archipelago by King Aenghus of Munster. Enda's churchyard is said to contain the graves of 120 saints, including his own, along with the remains of a decorated cross-shaft (left). In the north of the island, the mis-named 'Seven Churches' are dedicated to St Brecan, although it is likely they include a number of domestic buildings.

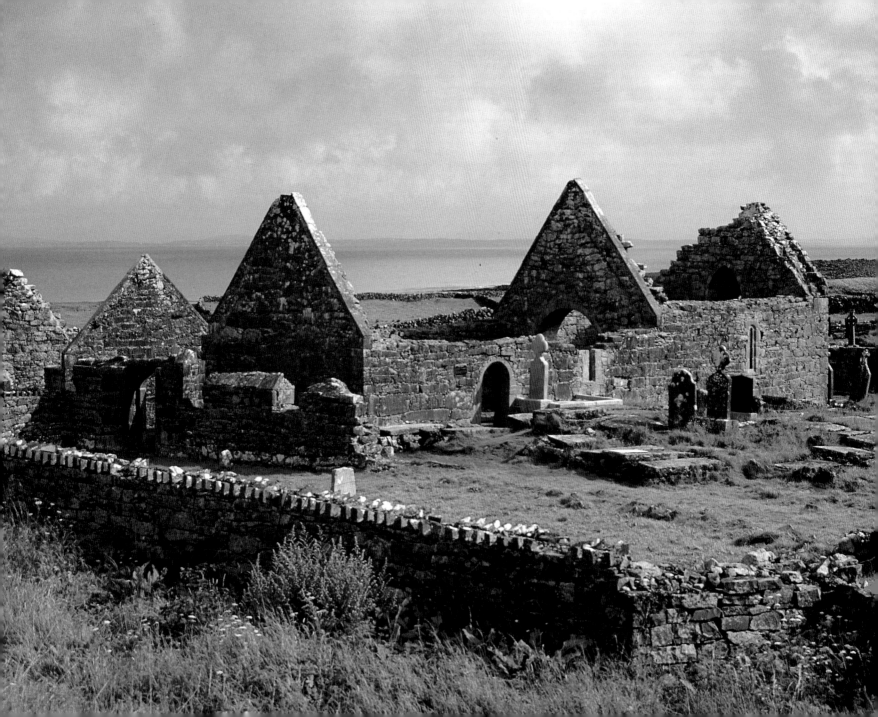

Sligo Bay, Co. Sligo

Right: THIS IS MAEVE'S REALM by the sea, pictured from the legendary site of her grave at Knocknarea. In early legend, she was the cruel queen of Connaught who sent her armies to war for the sake of a magic bull. At other times, she was portrayed as a goddess of war and sovereignty. She had the ability to change her shape at will, to run with the speed of a horse, and to sap her enemies of their strength. Her power even extended to Tara, where the high kings were obliged to mate with her before they were allowed to rule.

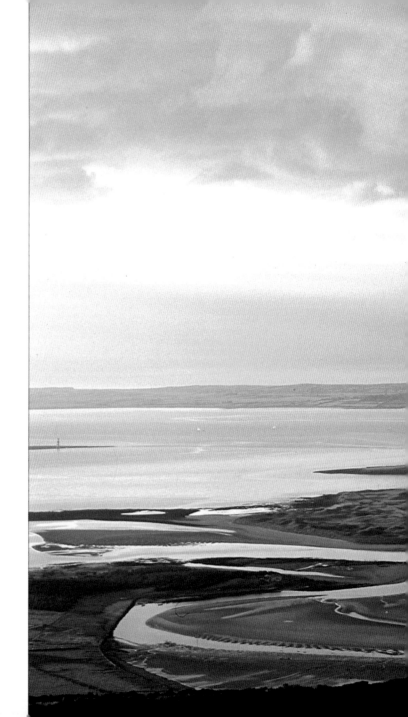

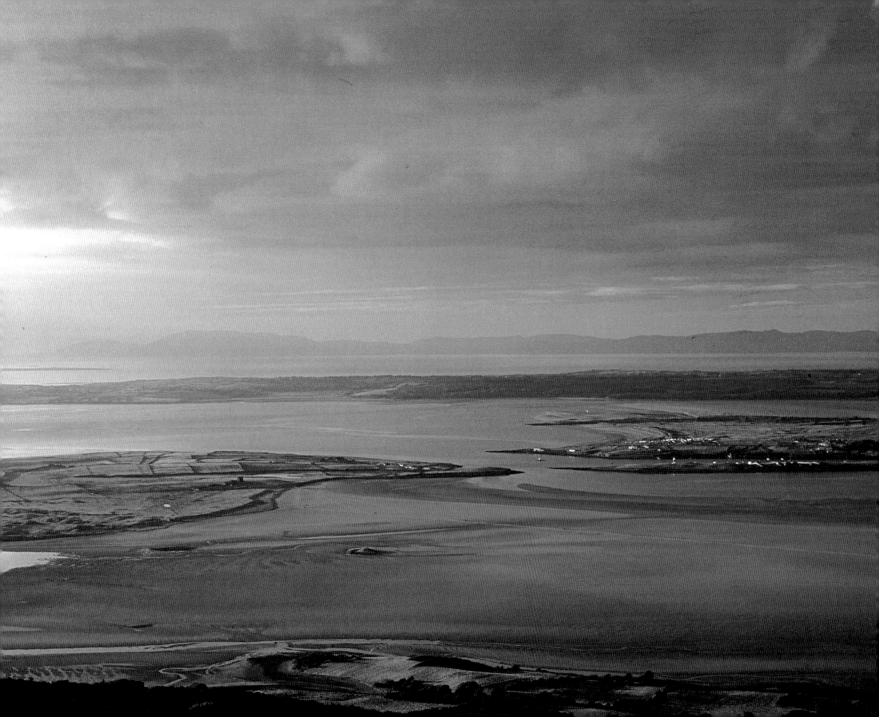

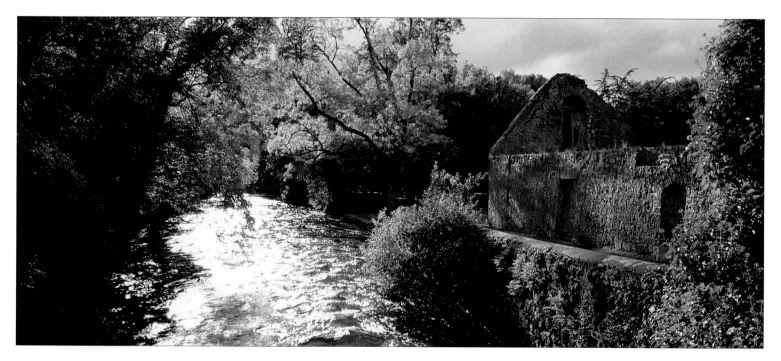

CONG ABBEY, CO. MAYO

Above: CONG ABBEY STANDS on the site of an ancient monastery, founded in the 7th century by St Fechin. This was taken over by the Augustinians in the early 12th century, a generous endowment by King Turlough O'Connor. Its profile was raised even further at the end of the century when it became the refuge of Rory O'Connor, the last high king.

Cong is most famous for its Celtic processional cross, which is now displayed in Dublin's National Museum. Perhaps the most interesting of the surviving buildings is the charming riverside fishing-house (right). The monks rigged up an ingenious system here, so that a bell rang in the kitchen whenever a fish was caught.

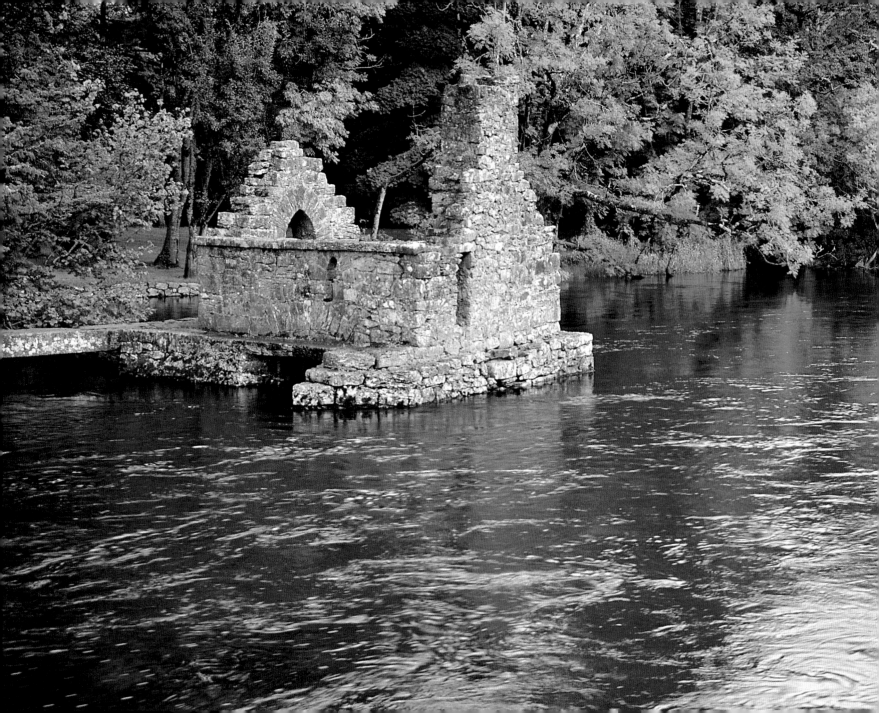

SLIEVE LEAGUE, CO. DONEGAL

Right: STORMY WATERS CHURN around at the foot of
Europe's tallest sea-cliffs. These rise to a majestic 601
metres (1,972 feet) above the Atlantic. Not surprisingly,
the sheer inaccessibility of the place attracted a number
of hermits. Chief among these were St Assicus and
St Aodh Mac Bric, whose dwelling-place is now marked
by a ruined oratory and a holy well. St Assicus was
known by the nickname of 'St Patrick's goldsmith', while
St Aodh was both a physician and a former prince of the
Uí Néill, the main Ulster dynasty of rulers. His name
was invoked by those suffering from headaches.

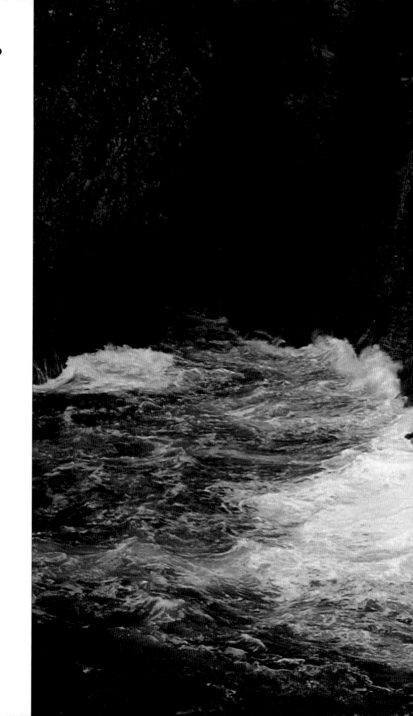

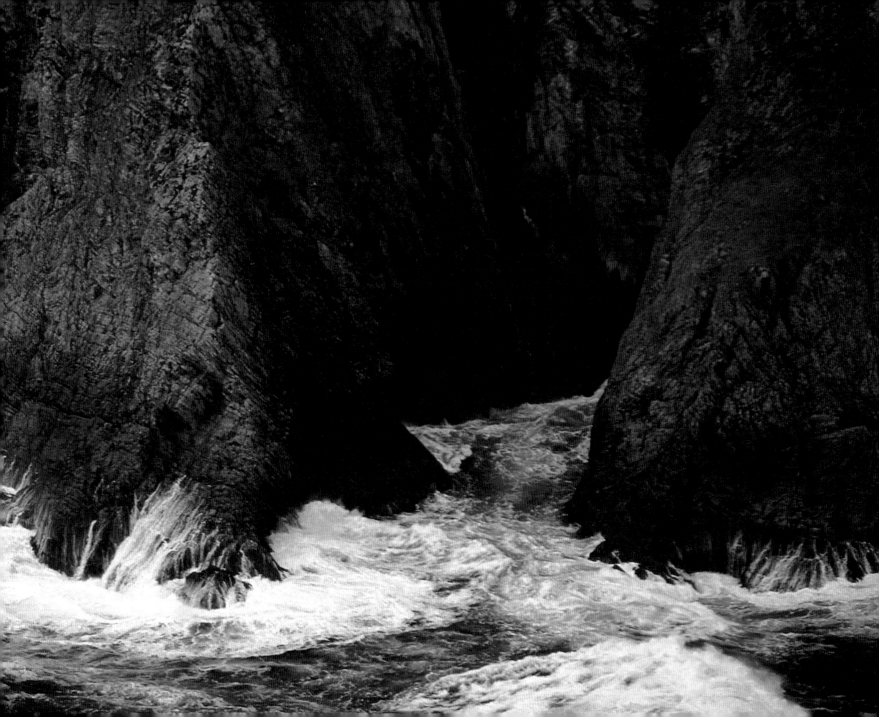

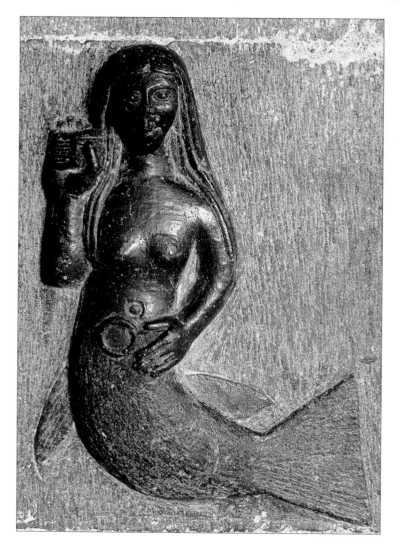

DOORWAY DETAIL, CLONFERT CATHEDRAL, CO. GALWAY

Right: In 558, a monastery was founded here by St Brendan, on a site called Cluain Fhearta, 'the Field of the Grave'. By the standards of his time, Brendan travelled widely – he visited St Columba in Iona and St Malo in Brittany – and this inspired a 10th-century monk to attribute a series of imaginary voyages to him. The book became a medieval bestseller, attracting many pilgrims to the original location of the saint's shrine. This may explain why the authorities commissioned such an elaborately carved entrance for the church.

MERMAID, CLONFERT CATHEDRAL, CO. GALWAY

Left: CARVINGS OF MERMAIDS were commonplace in medieval churches, where they represented the sins of lust and debauchery. This image was particularly powerful in Ireland, because of the ancient legend that St Patrick had turned pagan women into mermaids before banishing them. In addition, Clonfert's close association with Brendan the Navigator made the marine theme even more appropriate.

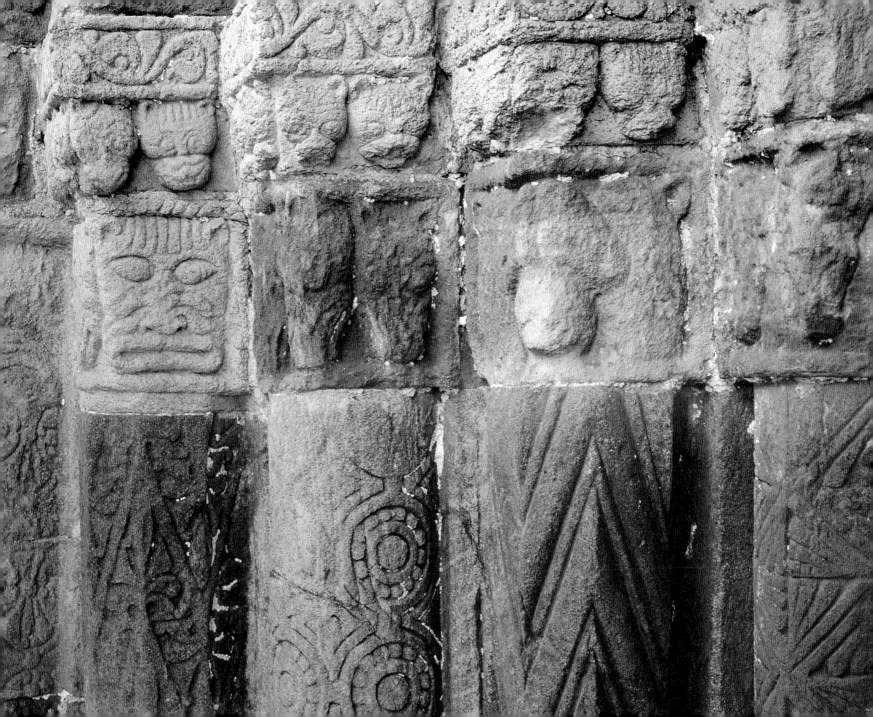

LOUGH CORRIB, CO. GALWAY

Right: DRYSTONE WALLS, shown here winding their way down a grassy hillside towards the shores of Lough Corrib, have been popular for centuries, especially in areas with little tree shelter. Lough Corrib itself is studded with tiny islets, most of which are deserted, although a few bear reminders of Ireland's warring past. The finest of these island strongholds is Hen's Castle, so-called because of a legend that the owners kept a magic hen, which laid enough eggs to feed the entire garrison during one particular siege. The castle once belonged to the feuding O'Flaherty chieftains, whose name can be linked to several other forts in the area. Among these is Aughnanure Castle, which was originally built in 1256.

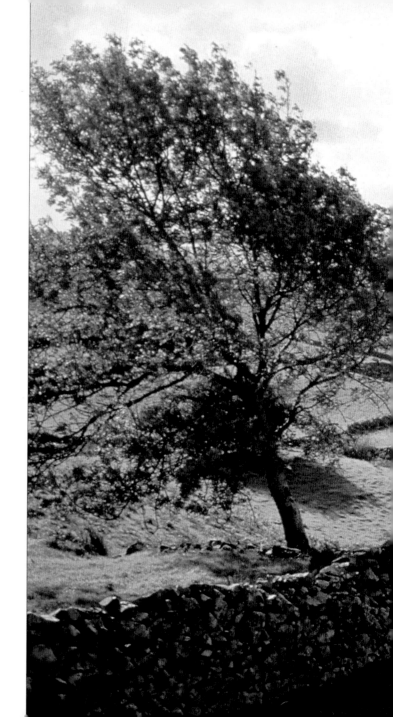

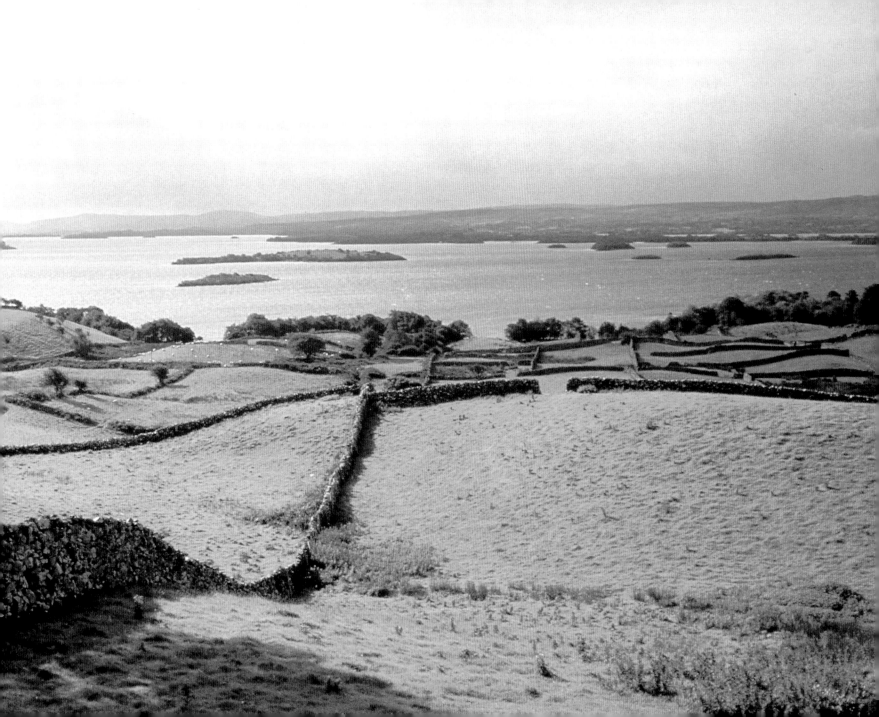

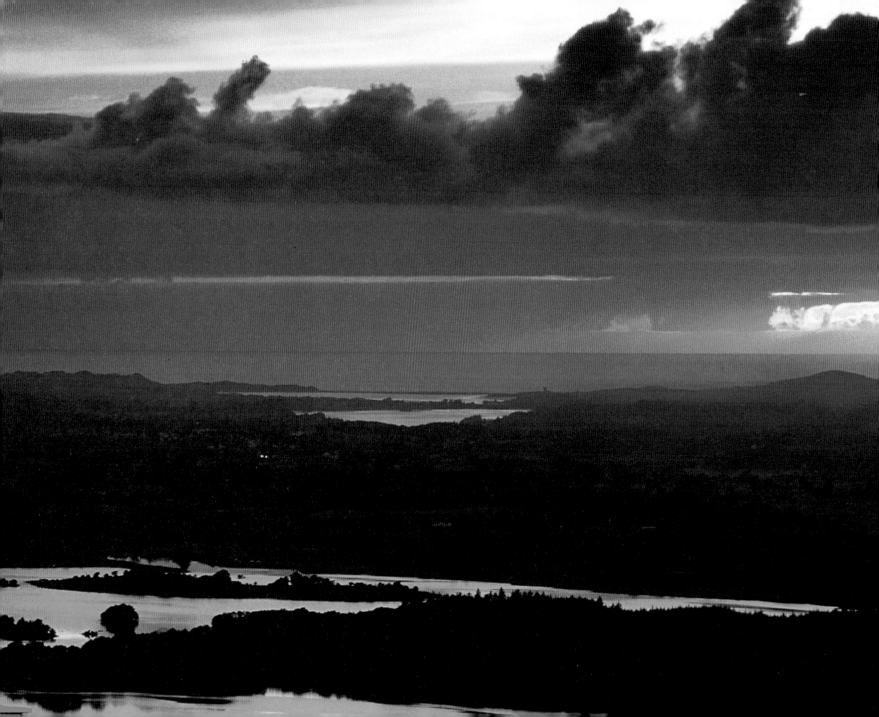

THE LAND OF
CÚ
CHULAINN

THE ANCIENT NAME of the northern *cóiced*, or 'fifth', was Ulaid, which subsequently developed into Ulster during the Viking age. The ultimate source of this word is uncertain, although there is a theory that it derived from Ollamh (or Ollave) Fódhla, a legendary high king of Ireland in the 8th century BC and the supposed founder of the triennal festival at Tara (see p. 85). Either way, the early history of the region was undeniably complex, as its territorial boundaries and the fortunes of its peoples shifted dramatically.

The high point of its influence occurred during the heroic age. Although undoubtedly written from

LEFT: LOWER LOUGH ERNE, CO. FERMANAGH

A westerly view of Lower Lough Erne, looking towards Donegal Bay. The site of Devenish monastery is nearby.

an Ulster perspective, the ancient tales about the exploits of the hero-warrior Cú Chulainn and his companions portrayed Ulaid as a large and powerful province. The Middle Kingdom had not yet been formed and most of its territories were under Ulster's control. Indeed, Cú Chulainn's home and the Cooley peninsula, where the main action of the Ulster cycle was set, are actually located in present-day Louth, and in the west Ulaid's influence appears to have extended as far south as Sligo Bay. At the heart of this mighty kingdom was the capital, Emain Macha, which archaeologists have linked with the important prehistoric site at Navan Fort (see p. 52). Its substantial remains emphasize that Emain Macha was once a place of both royal and sacred significance.

In the *Táin Bó Cuailnge* (*Cattle Raid of Cooley*), Cú Chulainn managed to protect Ulster from the armies of Connaught. In reality however the province was soon to be overrun and partitioned by its enemies. Traditionally, the first invasion was said to be the work of Cormac Mac Art, a high king who ruled in the 3rd century AD, but historical evidence suggests that it coincided with the emergence of the powerful Uí Néill dynasty two centuries later.

During the initial stages of Ulaid's decline, the central part of the province was occupied by a tribe known as the Airgialla

(subject peoples) and Emain Macha was destroyed, never to be rebuilt. Very little is known about this mysterious race of invaders. Some legends suggest that their attack was spearheaded by three brothers, the Collas, while others implicate three sons of Niall Noígiallach, one of sacred Tara's early kings. Either way, the Airgialla soon came to accept the overlordship of the Uí Néill and, shortly afterwards (c. 428), it was Donegal's turn to be conquered as Eoghan and Conall, two more of Niall's off-spring, transformed it into the new kingdom of Ailech.

With this development, most of northern Ireland lay in the hands of the two main branches of the Uí Néill dynasty, ruling from their twin capitals at Ailech and Tara. The remaining Ulaid people were compressed into the north-eastern sectors of their original territory, where they held sway over a number of minor tribes. One of these, the Dál Riata, had the distinction of owning land in both Scotland and Ireland. The dynasty was descended from Fergus Mór, son of Erc, who prompted some of his followers to migrate to Scotland, where

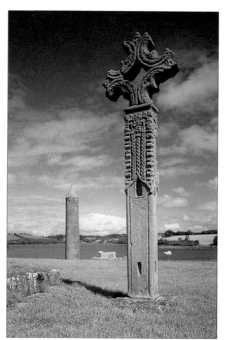

LEFT: DEVENISH ISLAND, CO. FERMANAGH

The monastery on Devenish (Ox Island) was founded in the 6th century by St Molaise. The 25-metre (81-foot) round tower features a sculptured cornice.

they established a settlement between the kingdom of Strathclyde and Pictland. This move appears to have taken place in the first half of the 7th century, just as the Irish Dál Riata were coming under threat from the Uí Néill of Ailech.

It was against this volatile political background that St Patrick's mission to Ireland took place. It is not always easy to separate fact from fiction in the saint's life but even so, it does appear that many of the key events in Ireland's conversion took place on Ulster soil. During his youth, after he had been carried off to Ireland as a slave, Patrick received God's call at Mount Slemish, Co. Antrim, where he was tending flocks of sheep. Later, when he returned as a missionary, he landed at Strangford Lough, by the mouth of the Slaney river. Then, at Saul (see p. 67), he gained both his first church and his first convert, after winning over a pagan lord named Dichu with his preaching. Finally, and most important of all, it was at Armagh that he decided to establish his ecclesiastical capital.

Patrick built his new church just two miles away from Emain Macha. Its name derives from Ard Macha (Macha's Height), confirming its link with the ancient stronghold. Usually such a move would imply that the founder was seeking secular protection for his church. In this instance, Emain Macha was already in ruins, so it is more likely that Patrick wished to emphasize the contrast between the glory of the Christian Church and a symbol of defeated paganism.

In time, Armagh's links with the cult of St Patrick made it the most influential city in Ulster. This did not shield it from all its enemies, for the church was desecrated by the Vikings and

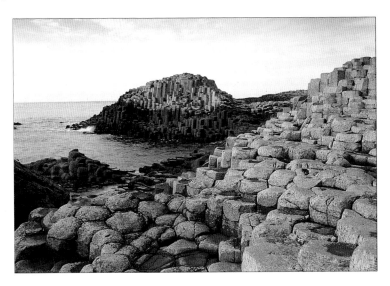

ABOVE: GIANT'S CAUSEWAY, CO. ANTRIM

The strange rock formations on the Giant's Causeway were created by a series of volcanic eruptions 60 million years ago. The lava cooled rapidly and as it did so, it shrank and cracked, leaving behind a honeycomb of hexagonal rocks.

looted three times by the Anglo-Normans. Even so, its prestige was raised in 1004 when Brian Boru, then king of all Ireland, acknowledged its primacy over the Irish Church, and again in 1152, when this was confirmed at the Synod of Kells.

Ulster also contained a number of Culdee churches, such as the Teampall Mór at Devenish. Culdee comes from the Irish *Céli dé* (servants of God) and refers to an austere group of settlements which flourished during the 8th and 9th centuries.

GIANT'S CAUSEWAY, CO. ANTRIM

Right: MANY LEGENDS HAVE attached themselves to
this geological miracle. Most of them relate to the
mythical hero, Finn Mac Cool. One story relates how a
giant Finn built a bridge from Ireland to Staffa, in order
to visit his beloved. The other end of this causeway was
Fingal's Cave – Fingal being the Scottish version of his
name. This ties in neatly with the facts, for the Giant's
Causeway was created by a series of volcanic eruptions,
which followed a vent stretching from Antrim to
the island of Skye.

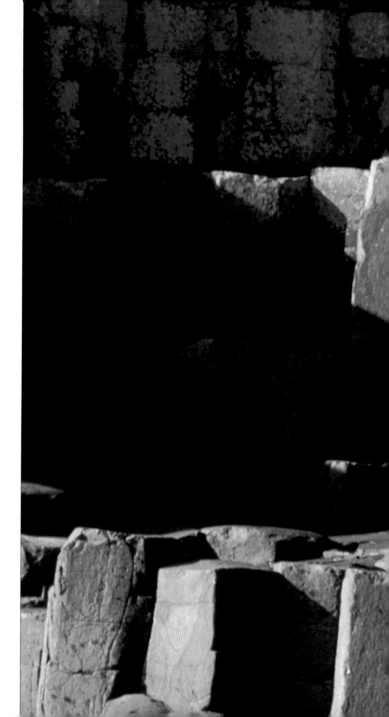

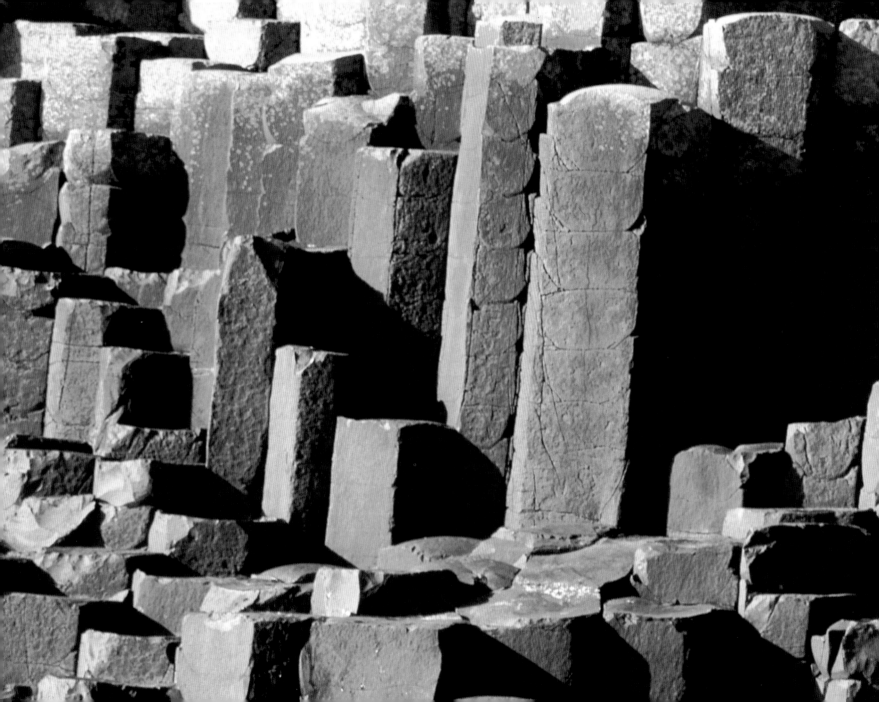

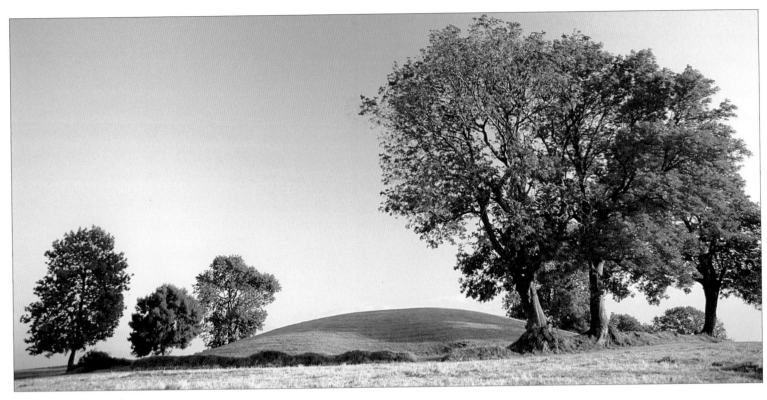

NAVAN FORT, CO. ARMAGH

Above: MOST AUTHORITIES equate this site with Emain Macha, the ancient seat of the kings of Ulster. According to legend, this gained its name when Macha, a horse-goddess, gave birth to twins, '*emhain*', after racing the royal steeds. Here, too, King Conchobar held court at the time of Cú Chulainn's exploits against the Connaught army.

The historical Navan Fort was scarcely less distinguished. Excavations have revealed that a series of huge, wooden structures was erected here between c. 700–100 BC, protected by a circular stockade. Other finds include the skull of a Barbary ape, perhaps an exotic gift to the chieftain who presided here.

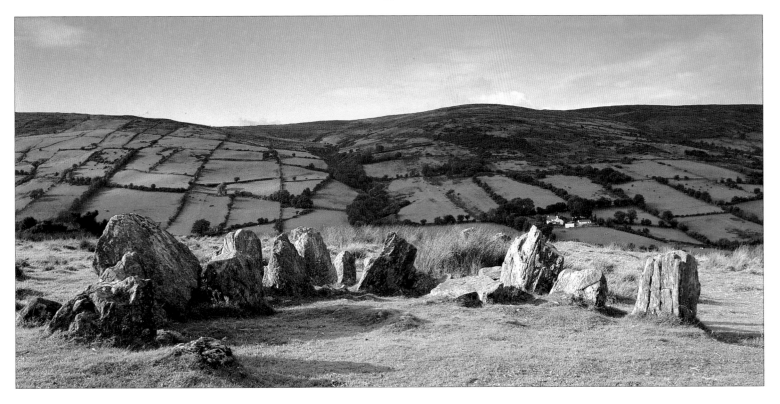

OSSIAN'S GRAVE, GLENAAN, CO. ANTRIM

Above: LOCAL LEGEND links this place with Ossian, a warrior hero whose adventures are related in the Fionn cycle of stories. He outlived his companions by travelling to Tir na Nog, the land of eternal youth, where he stayed for 300 years. Old age caught up with him however, when he set foot on Irish soil once more. In less fanciful terms, the stones form part of a Neolithic court cairn, a type of monument that is sometimes known as a 'lobster's claw', because its semi-circular row of stones is reminiscent of a pincer.

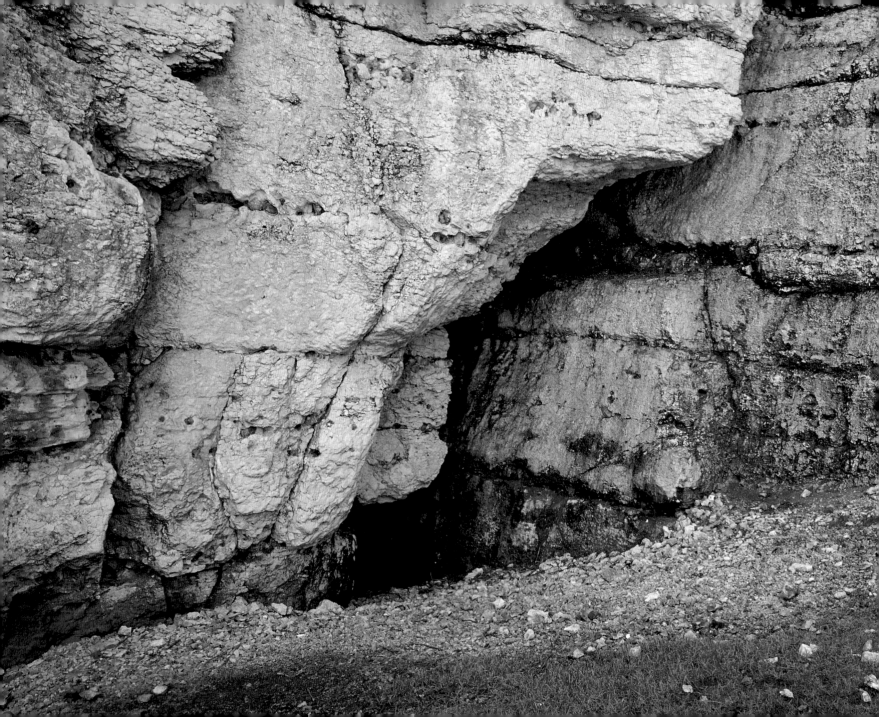

WHITE PARK BAY, CO. ANTRIM

Left: DURING THE NEOLITHIC AGE, when farmers
attempted to clear large tracts of wildwood, the axe was
a vital tool. The important axe 'factory' at Tievebulliagh,
a few miles south of White Park Bay, was the site of
many rich deposits of porcellanite rock. Northern
Antrim was a major source of production in this field,
and the axe-heads were brought here for polishing on
the basalt sand. There was a flourishing trade in
Tievebulliagh axes, and examples have been found as
far away as the Thames Valley, England. Using such a
tool, it has been shown that a man could fell a tree in
seven minutes and level 0.2 hectares (half an acre)
of scrubland within a week.

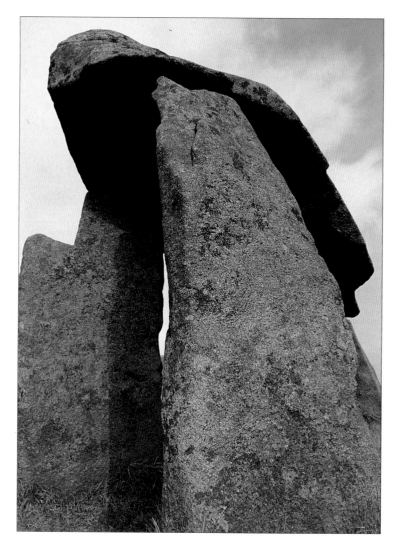

LEGANANNY DOLMEN, CO. DOWN

Left: SITUATED AT THE EDGE of the Mountains of Mourne region, this is one of the simplest portal dolmens, consisting of nothing more than three upright stones and a capstone. Its resemblance to an outsized table is apt, since the term 'dolmen' derives from two Breton words – *maen* and *taol*, which mean 'stone table'. This, in turn, may reflect old superstitions that dolmens were originally druid altars or giants' tables.

CRANNÓG, LOUGH NA CRANAGH, CO. ANTRIM

Right: CRANNÓGS ARE LAKE-DWELLINGS on artificial islands, mostly formed out of a mixture of brushwood and peat, ringed with a palisade of timber – hence the derivation of the term from *crann*, the Irish word for tree. This example is more elaborate, however, as the material is held in place by a stone wall. Most crannógs belonged to persons of high rank, as their construction required considerable manpower. They remained in common use for a remarkably long period of time, from the Neolithic era through to the late Middle Ages.

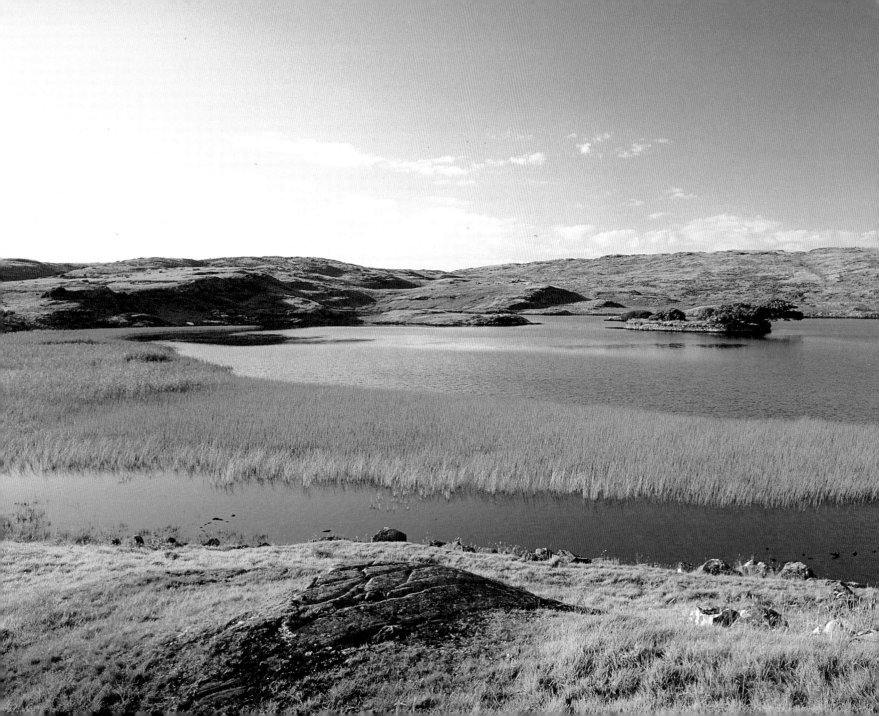

WHITE PARK BAY, CO. ANTRIM

Right: IT IS NOTORIOUSLY DIFFICULT to ascertain the
lifestyle of prehistoric shore-dwellers because, ever since
the 19th century, amateur collectors have disturbed sites
and removed finds. Nevertheless, it is clear that White
Park Bay was the focus of much activity. Some people
lived in caves, while others built circular wooden huts,
using stones at the base to wedge the logs into place.
Smaller finds have consisted mainly of implements.
The most commonplace are scrapers, curved pieces of
flint used for smoothing wood or cleaning out animal
hides. Hammers, awls and tranchets (sharpeners)
have also come to light.

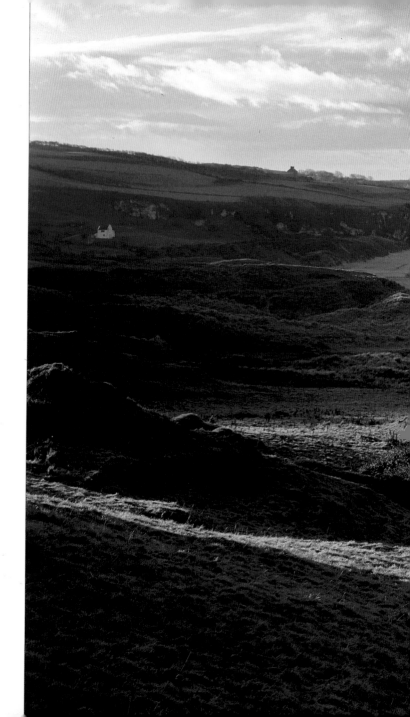

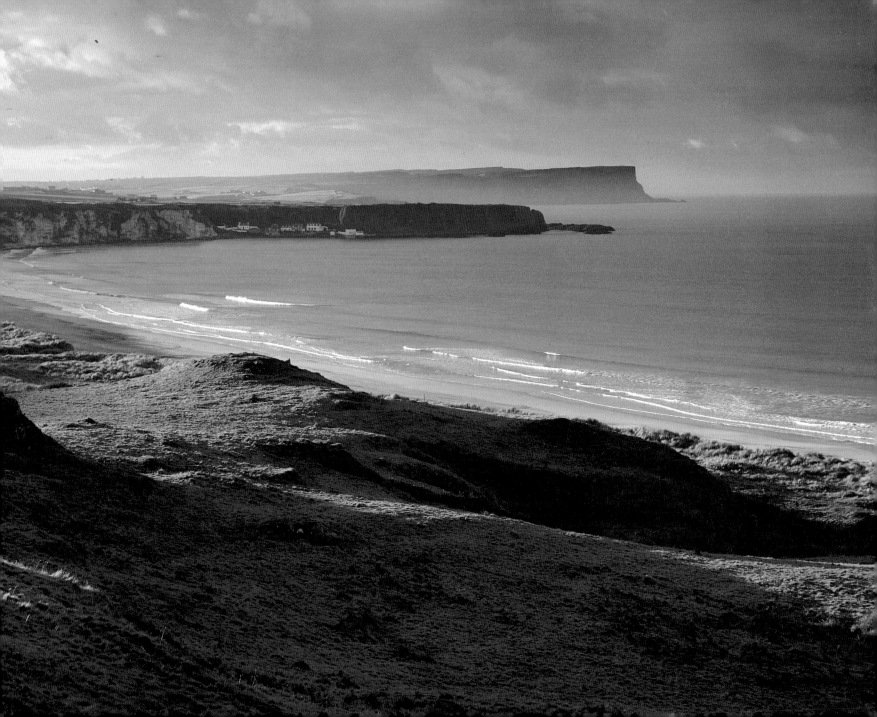

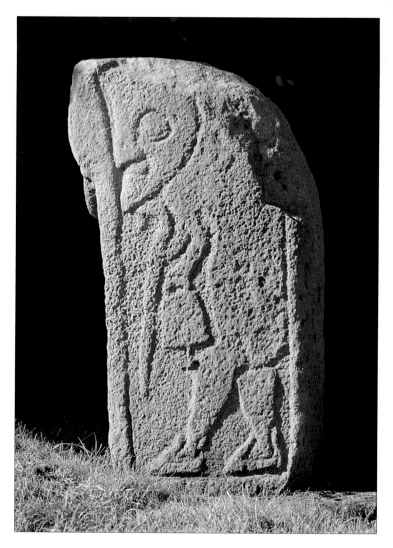

KILLADEAS, CO. FERMANAGH

Left: IN THE GRAVEYARD AT Killadeas there are three carved stones, dating back to the 8th or 9th century. The finest of them, known as the Bishop's Stone, portrays a stooping figure carrying a crozier and handbell. Both of these items were commonly associated with early Celtic saints and were frequently preserved as reliquaries.

LONGSHIP CARVING, DUNLUCE CASTLE, CO. ANTRIM

Right: THE GAUNT RUINS OF Dunluce Castle perch precariously upon a steep cliff-face. Its inhabitants were battered by the elements and once, many centuries ago, a violent storm sent the kitchen quarters crashing onto the rocks below. Bad weather was sometimes welcomed as it kept away the Viking longships – inspiring an unknown poet to pen the following lines:

Bitter is the wind tonight,
It tosses the ocean's white hair;
This night I do not fear the warriors of Norway
Coursing wildly on the Irish Sea.

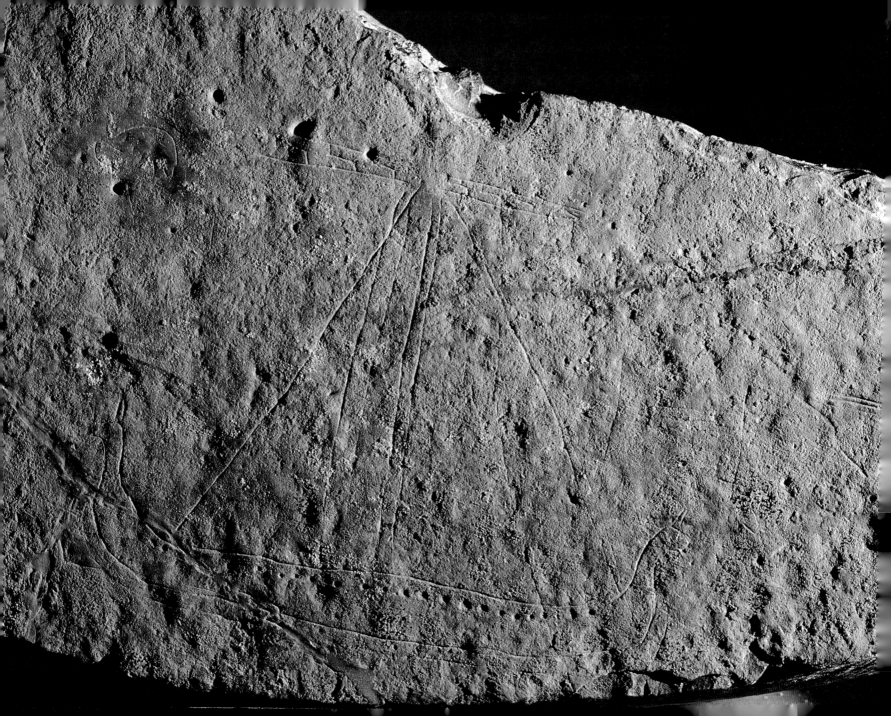

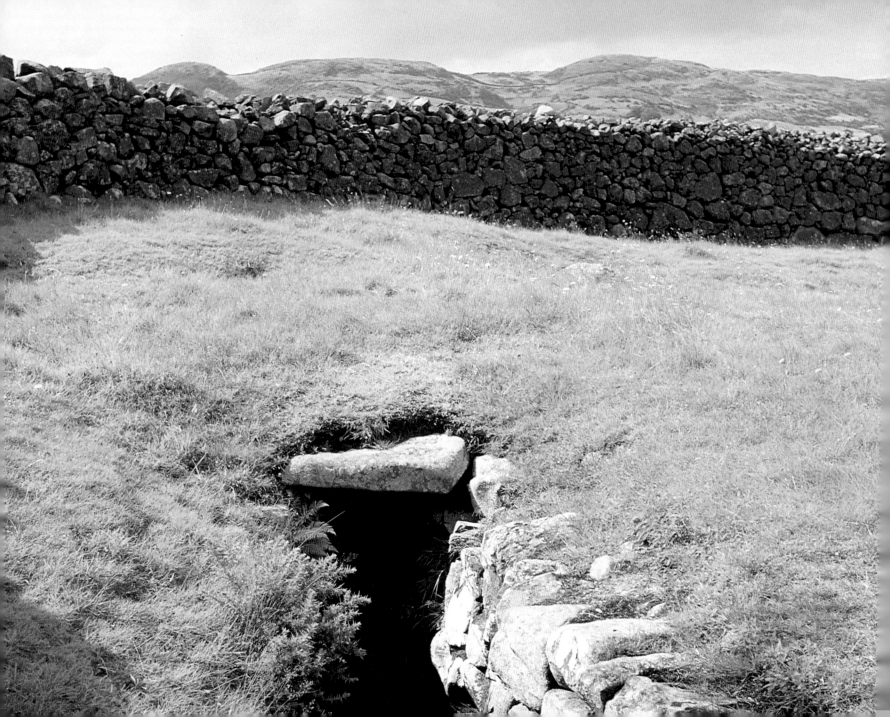

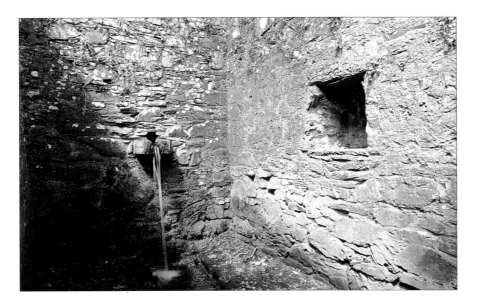

SOUTERRAIN, DRUMENA CASHEL, CO. DOWN

Left: IN COMMON WITH many other ringforts, the settlement at Drumena Cashel included a souterrain. This type of structure was a man-made underground gallery, lined with drystone slabs. Initially, a deep trench was dug, allowing the stone walls and lintels to be inserted. Then the passage was covered over, so that it was barely visible above ground. Souterrains were mainly used for storage purposes, although they could also act as refuges in times of danger. To this end, some souterrains contained hidden chambers.

FEMALE BATH-HOUSE, STRUELL WELLS, CO. DOWN

Above: THIS BATH-HOUSE is one of four healing wells at Struell. The first provided drinking water, the second was for the eyes, and the remaining two were for bathing the limbs. By tradition, the waters owe their therapeutic powers to the fact that St Patrick himself used to bathe here. Accordingly, on Midsummer's Eve, ailing pilgrims would gather at St Patrick's Seat, a local rock formation, circle it seven times, and then immerse themselves in the healing waters.

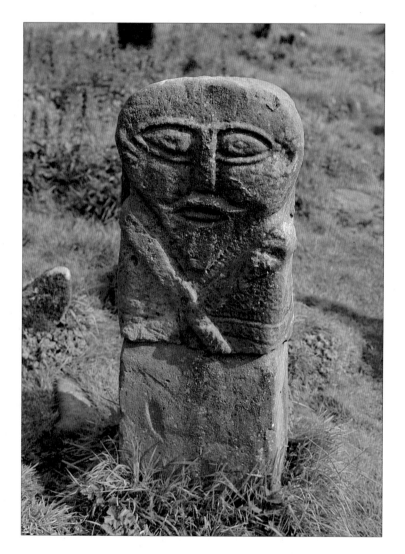

BOA ISLAND, CO. FERMANAGH

Left: THE JANUS FIGURE, on Boa Island, was thought to serve a
protective purpose, warding off evil from all sides. Boa Island took
its name from Badb, the goddess of war and death, and the area
remained an important druidic centre long after Christianity
had taken root in other parts of Ireland. In the lakeside cemetery of
Caldragh, remote and strange, two stone idols peer out from the
undergrowth (right). The figures may date from the Christian era,
but their inspiration is entirely pagan. The huge, pear-shaped
faces – one of them a double-sided Janus head – carry echoes
of the pillar-stones that were erected over some of the
earliest Celtic grave-mounds.

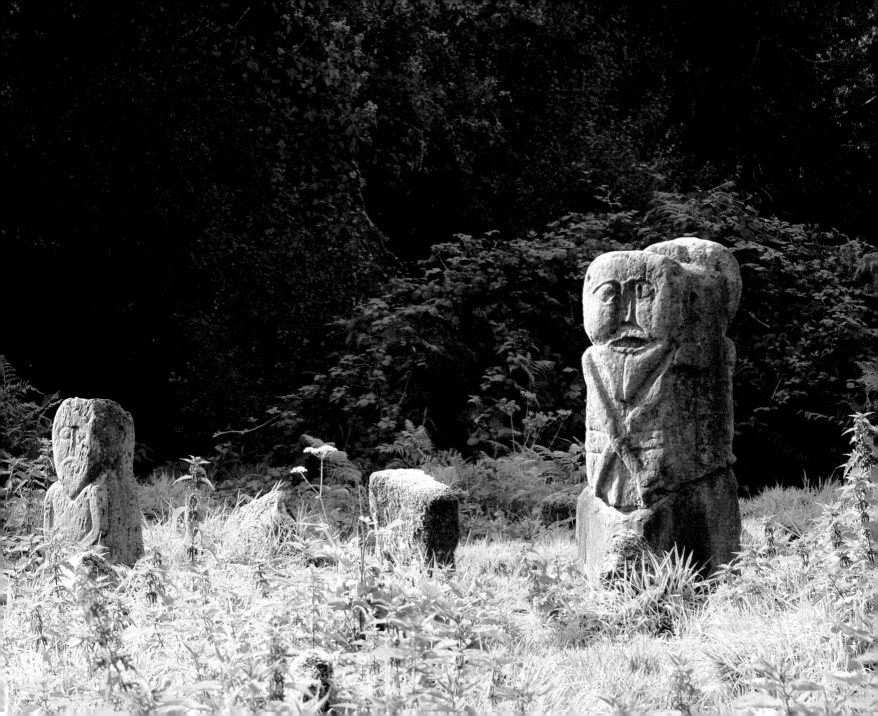

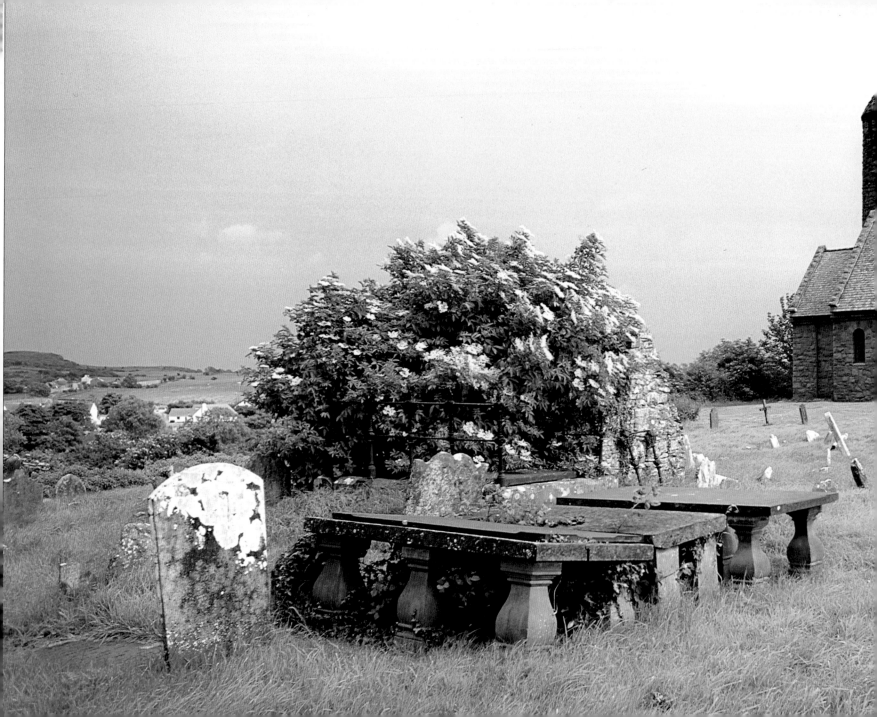

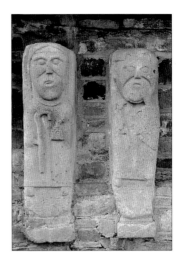

WHITE ISLAND, CO. FERMANAGH

Above: THE MASK-LIKE faces and bulging eyes of these pillar carvings are characteristic of pagan Celtic sculpture, but these were probably designed for Christian churches.

SAUL, CO. DOWN

Left: THIS CHURCH was built to commemorate the site of 'Patrick's Barn', the first grant of land to be offered to the saint. Nothing remains of the original foundation, although there are two very ancient mortuary houses in the graveyard.

INCH ABBEY, CO. DOWN

Right: THE PICTURESQUE remains of Inch Abbey
are set on marshy land on the banks of the river Quoile.
Originally this was the site of a Celtic monastery, but
the place was sacked in 1002 by a band of Viking raiders.
Then, in 1180, the abbey was occupied by the Cistercian
monks of Carrick Abbey, whose home had been
destroyed. The land was bestowed by John de Courcy,
an Anglo-Norman freebooter who had effectively
established himself as an independent prince of Ulster.

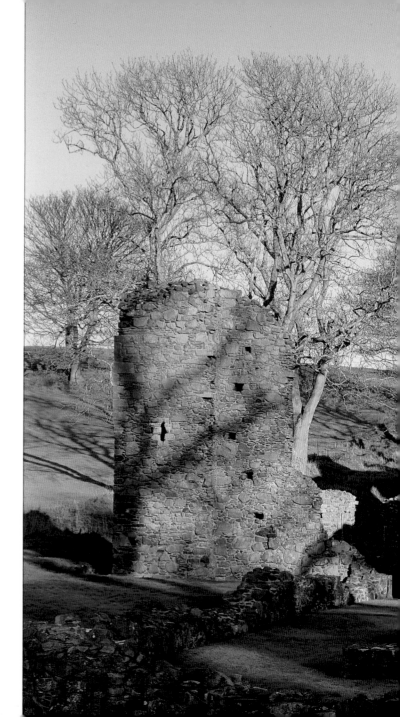

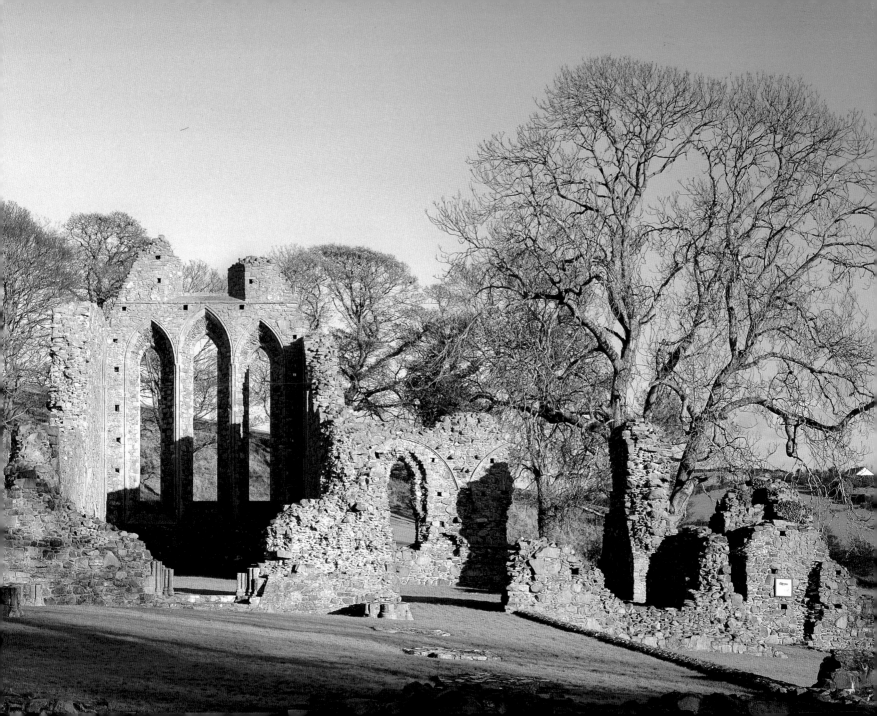

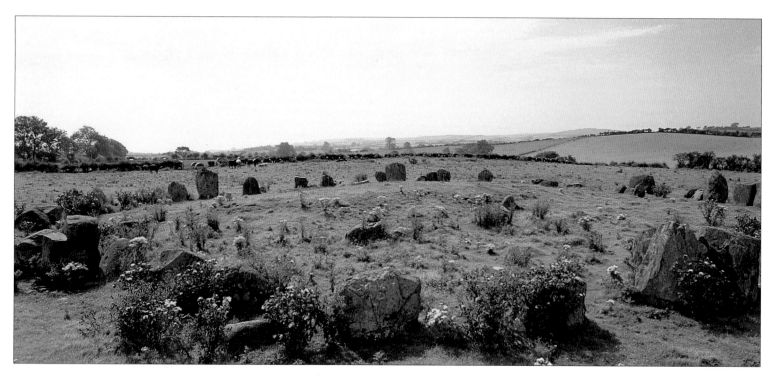

BALLYNOE, CO. DOWN

Above: THE STONES AT BALLYNOE form an unusual burial site. Within the outer ring is a low cairn, surrounded by a second row of boulders. Cist-graves have been discovered at either end of the cairn, along with cremated remains and some shards of Neolithic pottery. There is also a number of larger portal stones, which are aligned towards the equinoctial sunset.

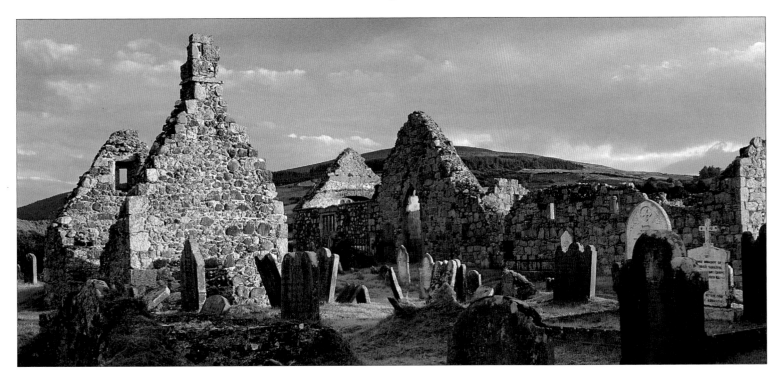

BONAMARGY FRIARY, BALLYCASTLE, CO. ANTRIM

Above: NEAR THE RESORT OF Ballycastle, the tranquil ruins of this old
Franciscan friary offer few hints of the district's troubled past. The MacDonnells
fought a pitched battle here with an English garrison, and many of the earls of
Antrim lie buried in the vault. In ancient legend too, the area was a place of ill
omen; the children of Lir were banished to this stretch of coastline for 300 years
after they were transformed into swans by their stepmother.

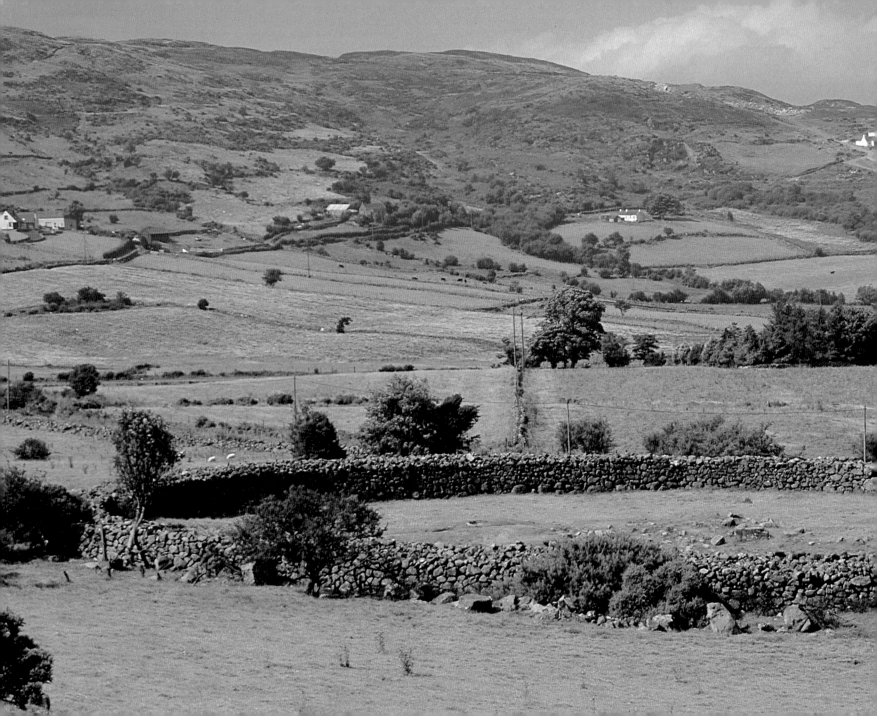

DRUMENA CASHEL, CO. DOWN

Left: IN ESSENCE, cashels are ringforts, which have walls made out of stone rather than earthworks. They are comparatively rare in Co. Down – only 57 have been detected – and their presence is largely confined to high, rocky areas, where deposits of stone were plentiful. The cashel at Drumena is one of the more straightforward examples. The outer wall is extremely thick, averaging around 3.4 metres (10½ feet), but there is no external ditch. It is composed of two layers of drystone, covering a core of rubble. Within the enclosure, excavations in the 1920s revealed a souterrain and traces of another drystone structure. The dating of cashels can only be very tentative, but this one is thought to have been built in the early Christian period.

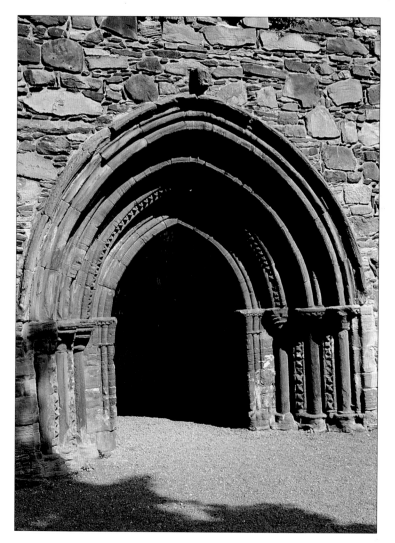

GREY ABBEY, CO. DOWN

Right: GREY ABBEY IS one of the best-preserved Cistercian houses in
the country. Its monks came from Holm Cultram in Cumbria and it
was founded in 1193 by Affreca, the wife of John de Courcy (see
pp. 68–69) and daughter of King Godred of Man. The Cistercians
had a reputation for producing sober, restrained architecture, with a
minimum of fussy decoration. Indeed their leader, St Bernard, made
a point of denouncing the grotesque creatures found on so many
romanesque churches. Instead, Grey Abbey is notable for its
pioneering use of the gothic style, most evident in the elegant arch
of the elaborate West door (left).

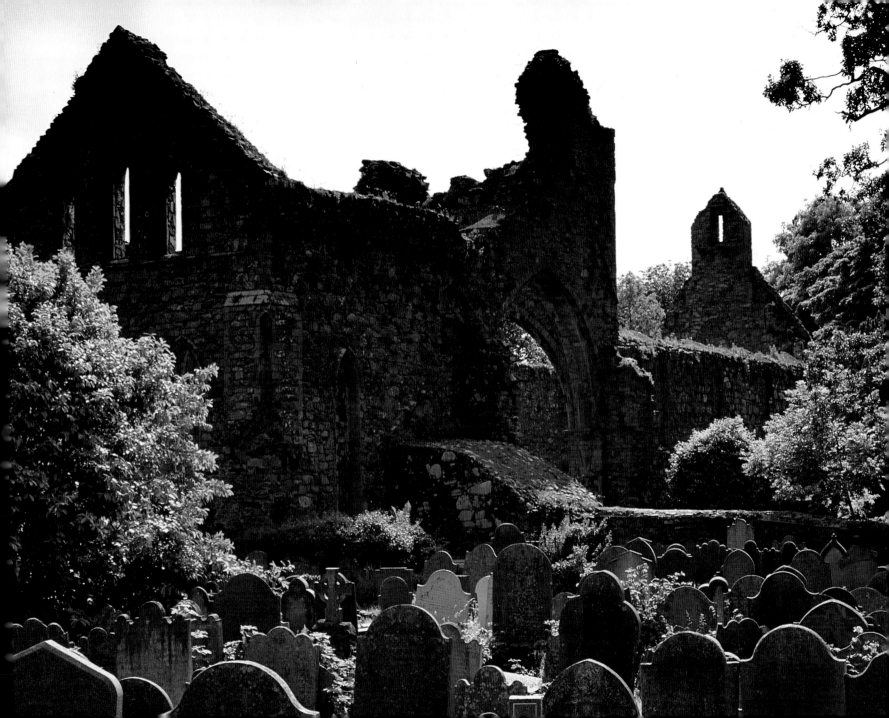

MONEA CASTLE, CO. FERMANAGH

Right: THE BRITISH CROWN attempted to establish a permanent presence in Ireland from the late 12th century, originally through a series of settlements known as 'plantations'. Early attempts to establish these in Munster and the Midlands were largely unsuccessful, but the policy fared better in Ulster. Monea Castle was built in 1618–19 by a planter, Malcolm Hamilton, the rector of Devenish. Memories of his original homeland appear to have been uppermost in his mind, for the striking barrel towers and crow-stepped gables lend a very Scottish air to the place.

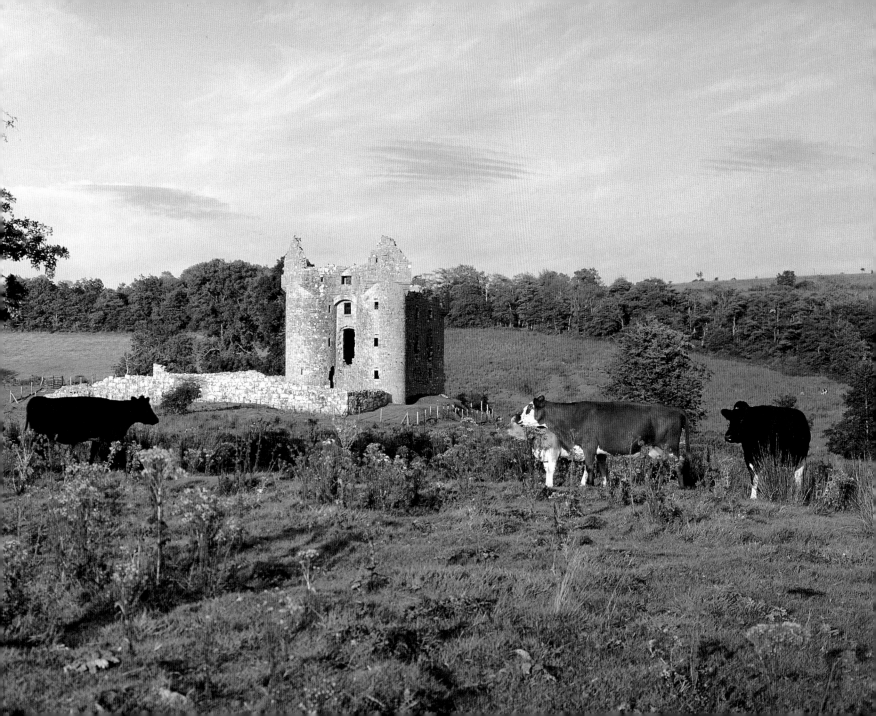

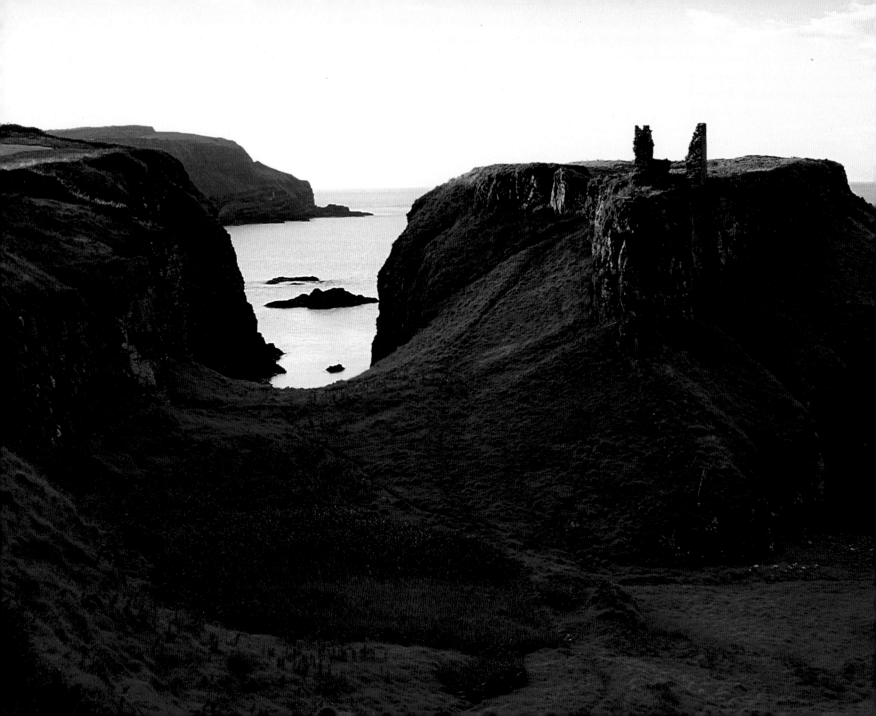

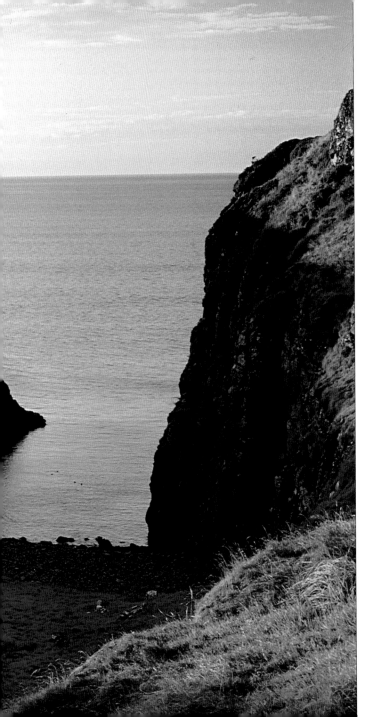

Dunseverick Castle, Co. Antrim

Left: DUNSEVERICK WAS built on the site of an ancient promontory fort, Dun Sobhairce, 'Sobhairce's fort'. Little is known of its early history, although it seems to have been important, as there was a road linking it directly to the holy site of Tara. The Vikings pillaged the place in 870 and 934, and the Irish, in turn, used it as a departure point for their raids on Scotland. St Patrick is said to have ordained St Olcán here, presenting him with the relics of the Apostles, Paul and Peter.

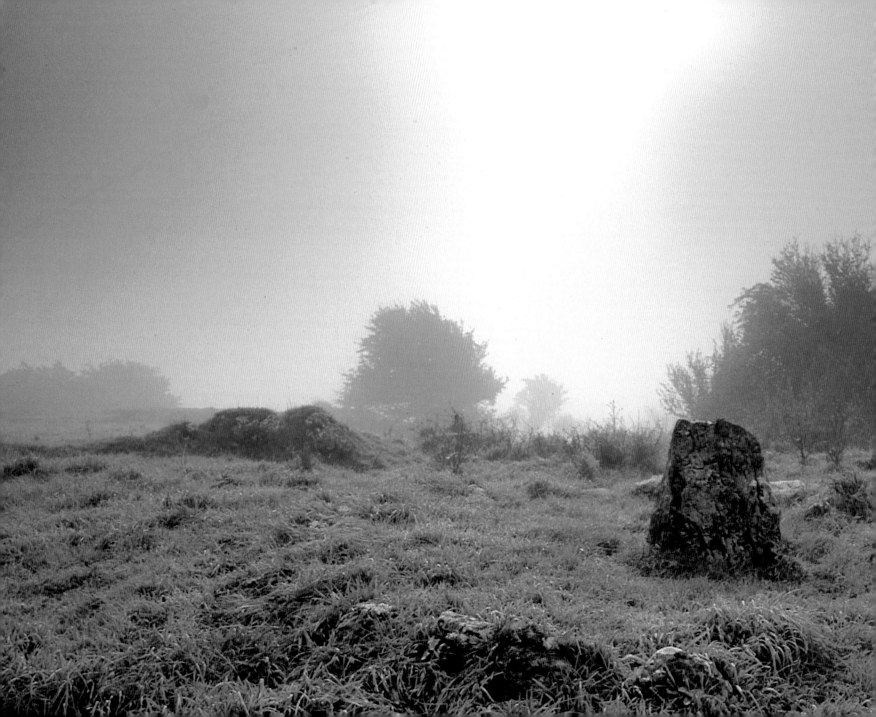

THE
MIDDLE
KINGDOM

THE MIDDLE KINGDOM was the most recently formed of the ancient divisions, the *cóiceda*, or 'fifths', and the only one that did not survive to become a modern province. It was centred around Mide (Meath) and was intended to act as a buffer-zone between the other warring lands. According to legend, it was founded in *c.* 130 AD by Tuathal Teachmhair, one of the early high kings. He chose the Hill of Ushnagh at Co. Westmeath (left), as the core of his new province, creating it from territories confiscated from the other districts.

For this reason the Hill of Ushnagh was often considered the mystical heart of Ireland. It was the

LEFT: THE HILL OF USHNAGH, CO. WESTMEATH

The mystical centre of Ireland and once the site of a pagan Beltane festival. Thirty-two counties are said to be visible from its summit.

setting for a major fire festival at Beltane, as well as the subject of a plethora of myths. The most exotic of these told how the wizard Merlin stole away with Ushnagh's impressive stone circle. Entering the place by moonlight, he uttered an incantation which caused the stones to uproot themselves and dance across the sea to England. There, they regrouped to form the circle of Stonehenge.

More than any other part of Ireland, the history of the Middle Kingdom was shaped by the splendour of its early monuments. In the sites of Newgrange and Tailte (now Teltown), it possessed two of the three great cemeteries of ancient times.

Tailte was named after the goddess Tailtu, the foster-mother of the sun god, Lugh. After her death he instituted the festival of Lughnasadh (a summer festival which falls on August 1st) and introduced a series of funeral games in her honour. These games, which were similar in concept to the Olympic Games, survived until the 12th century.

The grander monuments at Knowth (pp. 90–91) and Newgrange (pp. 86–89), persuaded locals that they were in the presence of gods, who resided in these stone temples. Newgrange, as the most impressive of the two monuments, was said to be the home of the Dagda, the father of the gods. In Irish myth, the gods were known as a race of ancient beings, known as the Tuatha Dé Danaan. They were thought to have ruled Ireland for many centuries until their defeat at the hands of a race called the Milesians. At this point, the Danaans retired to their *sidhe*, or fairy mounds, which were actually the burial mounds of prehistoric peoples. Although the *sidhe* appeared to be nothing more than simple, grassy mounds, legend has it that they concealed luxurious palaces where the gods devoted themselves to pleasure. A few ancient passage-graves featured carved decoration – such as the spiral motifs at Newgrange and the geometric patterns at Fourknocks (see p. 83) – indicating their significance as ritual sites. Other tombs, like the dolmen at Proleek (left), are more notable for their legendary associations.

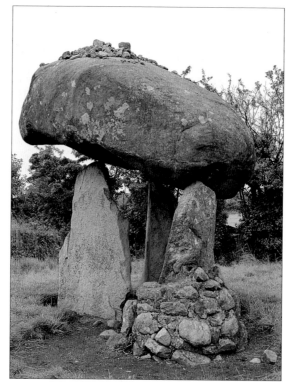

LEFT: PROLEEK DOLMEN, CO. LOUTH

This dolmen is also known as the Giant's Load. Its name may refer to a nearby wedge-tomb, which belonged to a Scottish giant who crossed swords with Finn Mac Cool.

In historical terms the most influential prehistoric site in the Middle Kingdom was Tara (pp. 84–85). From a very early stage this was seen as the royal seat of the high kings, the most sacred place in pagan Ireland. Candidates were selected by the druids in a mystic ceremony known as the *tarbhfhess* (bull-sleep). After this, the prospective king had to participate in a ritual union with the earth-goddess. This *feis*, or ritual mating, was designed to ensure the prosperity of the land, since the fertility and wealth of the kingdom were thought to reflect the fortune and character of its ruler. This meant, among other things, that the king had to be free from any physical or moral blemish, and early storytellers related several tales about kings who were forced to abdicate after becoming scarred or disfigured in the course of a battle.

Tara was also the site of an important triennial festival which attracted chiefs, bards and historians from all parts of the land. At this assembly laws were passed, disputes were settled and clan genealogies were put on record. All enmities were laid aside during this period, and the event was celebrated with great feasting and music-making.

The historical realities of the high kingship of Tara are hard to assess. Ancient lists drawn up by the bards gave the names of 107 high kings before 1 AD, with a further 81 after that date, before the title disappeared in the 12th century. Most of these kings, however, were mythical; the first character of any real substance was Niall Noígiallach (Niall of the Nine Hostages), who appears to have lived during the early 5th century. Niall was the founder of the influential Uí Néill dynasty and gave his

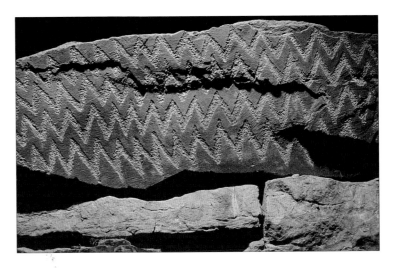

ABOVE: FOURKNOCKS PASSAGE TOMB, CO. MEATH

Geometric design from the passage-grave at Fourknocks, which contained the remains of 65 people. Carvings of this kind are called scribings.

name to the Mound of the Hostages, one of the burial places at the seat of Tara.

Whether or not the high kingship entailed any real power is questionable, but it was certainly a source of prestige. Later rulers were eager to claim the title, although it only made them nominal overlords of other Irish chiefs.

The authority of Tara gradually declined under pressure from the Church, symbolized in the legendary battle between St Patrick and the high king. The Saint's triumph represented the victory of Christianity over the seat of pagan power.

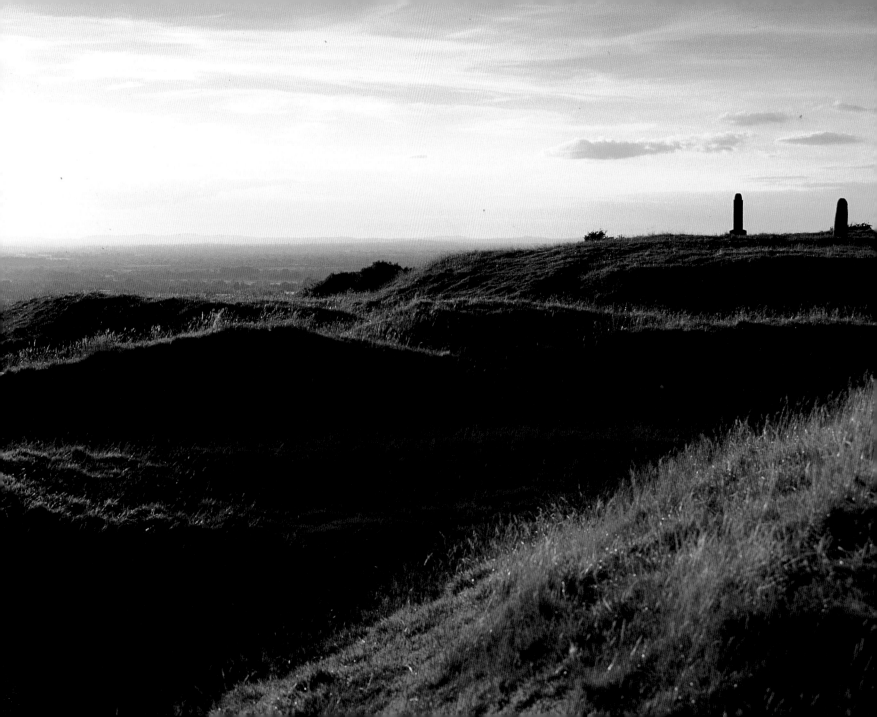

The Royal Seat Of Tara, Co. Meath

Left: TARA WAS THE HOLIEST SITE in ancient Ireland. It was the seat of the high kings, where candidates were selected by the druids in a mystical ceremony known as the *tarbhfhess* (bull-sleep). These were confirmed at the Lia Fáil, the Stone of Destiny (right), which was supposed to scream aloud when touched by the rightful king. The importance of the site dates back to the Neolithic Age, when the Mound of the Hostages – a monumental passage-grave – was constructed. It was still revered centuries later, when the place was seized by the Uí Néill dynasty, at the dawn of Irish history. Even after this, Tara continued to exert its magic. In Christian lore, it was said to be the site of a cursing contest between St Ruadhan and Tara's pagan rulers, while medieval writers described a magnificent Banqueting Hall, worthy of an Arthurian-style court. As recently as 1899, British Israelites explored the area, hoping to find traces of the Ark of the Covenant.

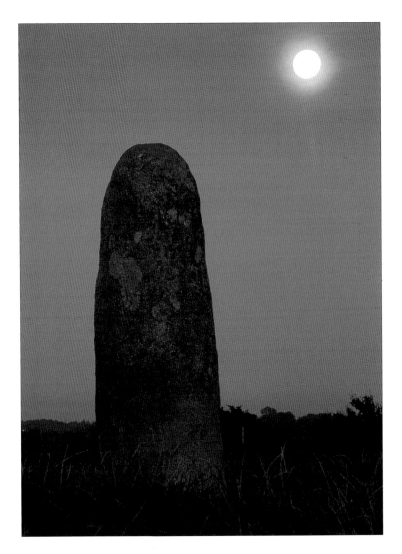

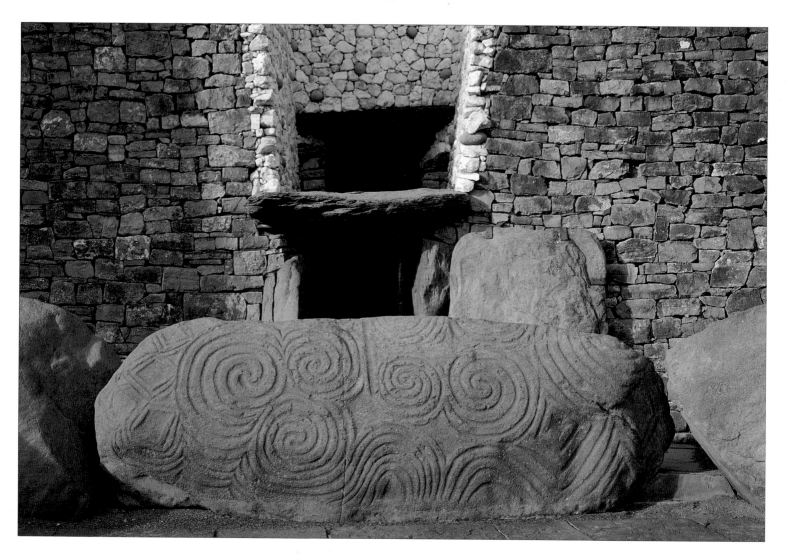

Passage Tomb, Newgrange, Co. Meath

Left: EARLY STORYTELLERS REGARDED Newgrange as a divine place, as it was the home of the Dagda, the father of the gods. It was stolen away from him by his son, Oenghus, who gave shelter to a runaway couple called Diarmaid and Gráinne (pp. 20–21) The heroine of this tale gave Newgrange (the Cave of Gráinne) its name. At dawn on the winter solstice, a thin shaft of sunlight enters through a specially constructed 'roof-box' and penetrates the entire length of the passage (right). Newgrange is also celebrated for its elaborate spiral designs (below), featured on the outer kerbstone and the inner walls of the tomb. In light of the monuments astronomical function, it is possible that they were meant to evoke the movement of the sun.

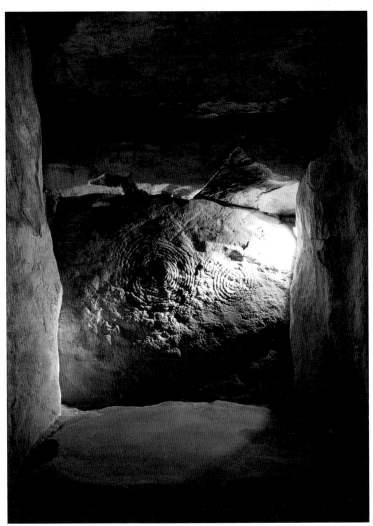

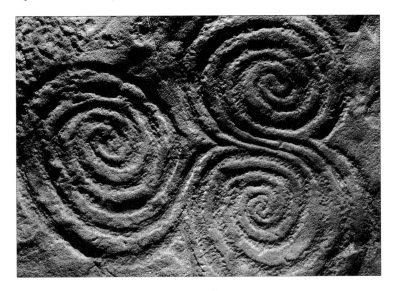

Corbelled Roof, Newgrange, Co. Meath

Right: Ireland's greatest prehistoric necropolis is the
Brug na Bóinne (Palace of the Boyne), a megalithic
complex situated a few miles west of Drogheda. At its
heart, there are three huge burial mounds – Newgrange,
Knowth and Dowth. Newgrange was occupied during
several different periods, although radiocarbon tests
suggest that the oldest parts may date back to around
3200 BC. The principal chamber rises to a height of
5.9 metres (19½ feet) and features a remarkable
funnel-shaped roof, created with early corbelling
techniques. This tomb was plundered in 862, when a
local princeling brought Norse raiders to the site.
Shortly afterwards, his eyes were put out, as a
punishment for his treachery. The entrance was then
covered over and Newgrange was forgotten until 1699,
when a team of roadbuilders happened upon it.

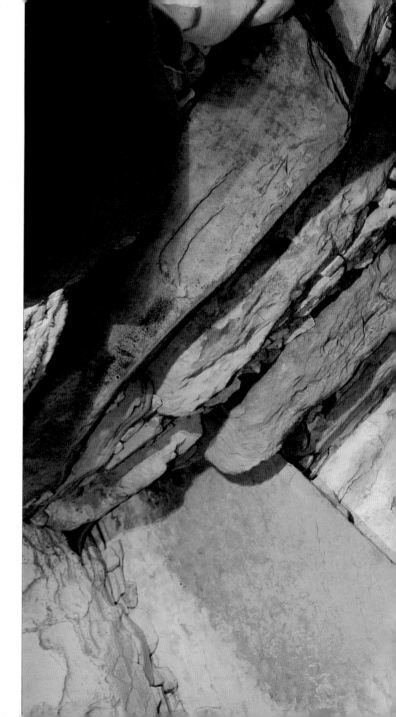

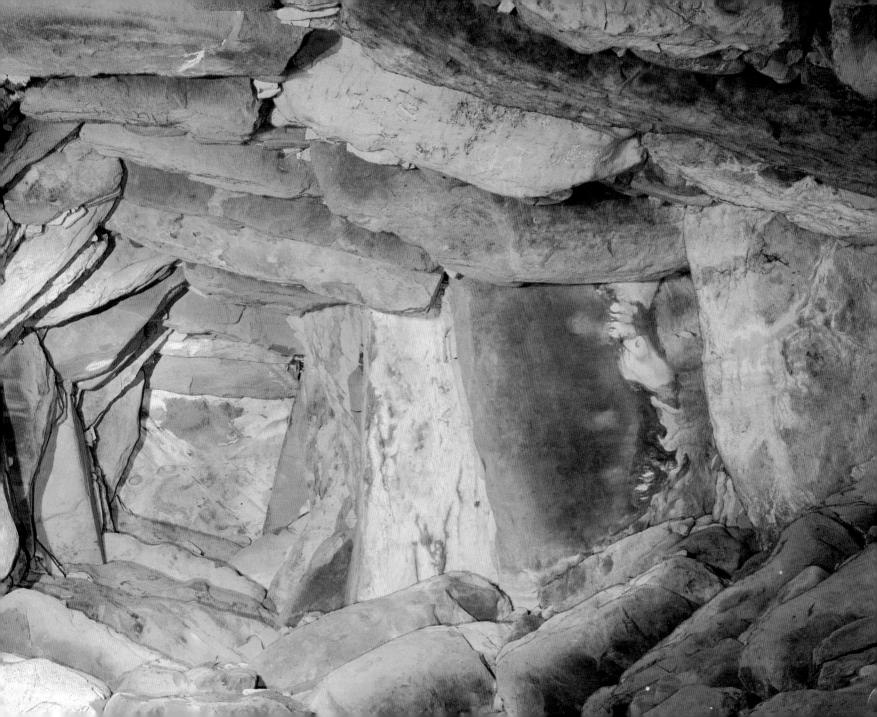

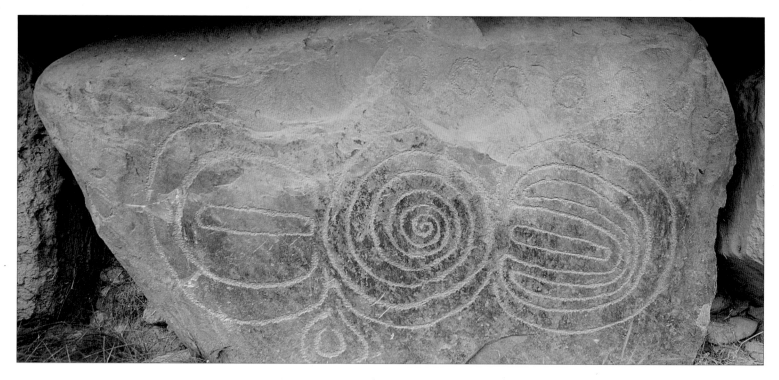

KNOWTH PASSAGE TOMB, KERB STONES, CO. MEATH

Above: ALTHOUGH ITS FAME has always been overshadowed by
Newgrange, the tomb of Knowth is scarcely less remarkable. The
eastern tomb terminates in a cruciform chamber with three niches.
Around the main cairn, there are more than a dozen smaller mounds,
each containing their own passage-grave. Much later, a network of
souterrains was also constructed within the Knowth complex.

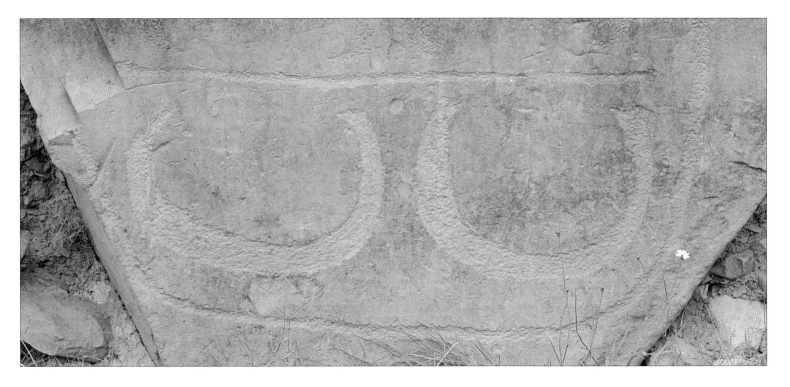

KNOWTH PASSAGE TOMB, KERB STONES, CO. MEATH

Above: THE SECRETS OF KNOWTH remained hidden for much longer than those of Newgrange. Its central cairn contains an arrangement of two passage-graves, constructed back-to-back and oriented towards the spring and autumn equinoxes. Inside, the stones are decorated with an array of circular and spiral grooves. The designs here come from a stone basin in the eastern tomb, which was used in ancient cremation rites.

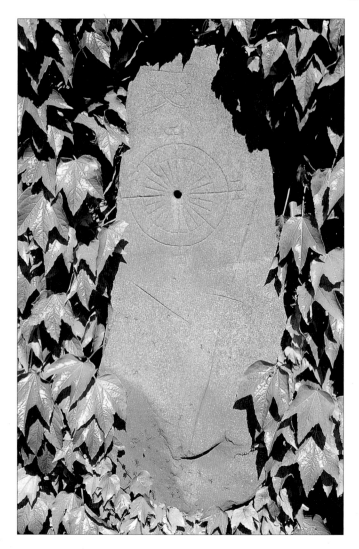

BROKEN CROSS & SUNDIAL, KELLS, CO. MEATH

THIS SITE OWES ITS FAME to the lavish illuminated manuscript, *The Book of Kells*, which was housed here for many centuries. The monastery itself was founded in the early years of the 9th century as a sanctuary for the monks of Iona, who had been driven out of their home by Norse raiders. Construction work was completed by 814, when Kells became head of the Columban federation of monasteries, the order following the teachings of St Columba. Mindful of the destruction threatened by the Vikings, many abbots commissioned stone crosses and sculpture as lasting memorials to their faith. At Kells, there are remains of five 10th-century crosses. The Broken Cross (right), would have been particularly imposing, reaching a height of around 6 metres (20 feet) and boasting a fine display of Biblical scenes. Here, the Fall is depicted. Adam and Eve are framed by the branches of the Tree of Knowledge while in the centre, the serpent coils round its trunk. Part of an early sundial has also survived (left). This would have been a common sight at many early churches, since it provided worshippers with their only reliable means of attending services on time.

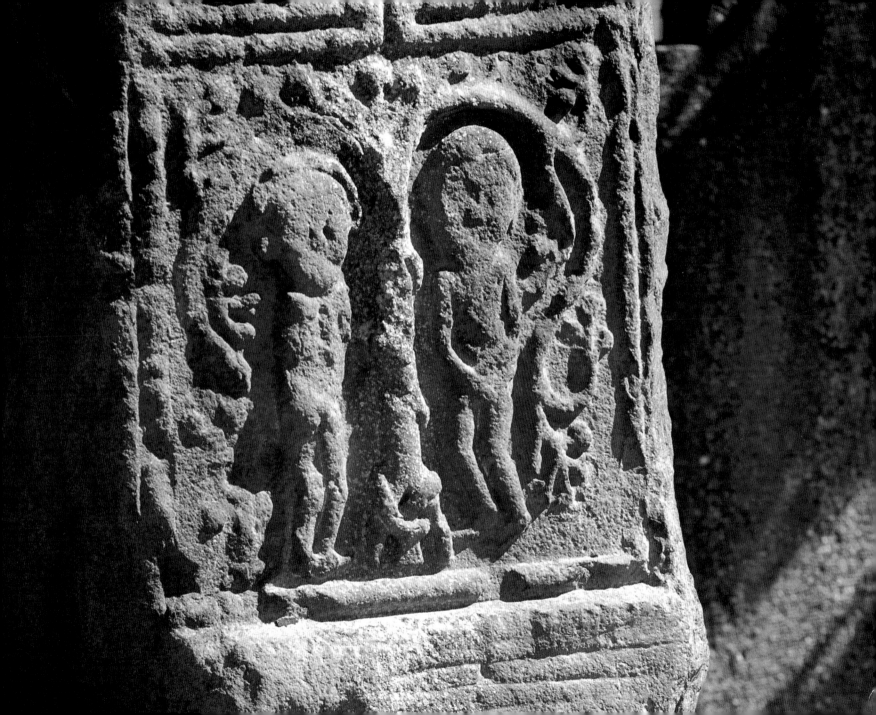

Dundalk, Co. Louth

Right: THIS 12TH-CENTURY motte and bailey were built
by Bertram de Verdon, an Anglo-Norman lord, to
protect his property in the surrounding countryside.
There are suggestions, however, that the castle was
constructed over a prehistoric ringfort. If so, it may well
be the Dún Dealgan (Dealga's Fort), which gave
Dundalk its name and which plays such a prominent
role in Irish legend – for this was the birthplace and
home of Cú Chulainn, the greatest of the ancient
warrior heroes. In the *Cattle Raid of Cooley*, the most
famous of the pre-Christian epics, Cú Chulainn used
Dealga's Fort as his base when defending Ulster against
the invading armies of Connaught. By day, he would
challenge their champions to single combat, and by
night, he would hurl down slingshots on the enemy
camp. Such was the ferocity of these attacks that, it was
said, no living man or beast dared to show their face
between Dealga and the sea.

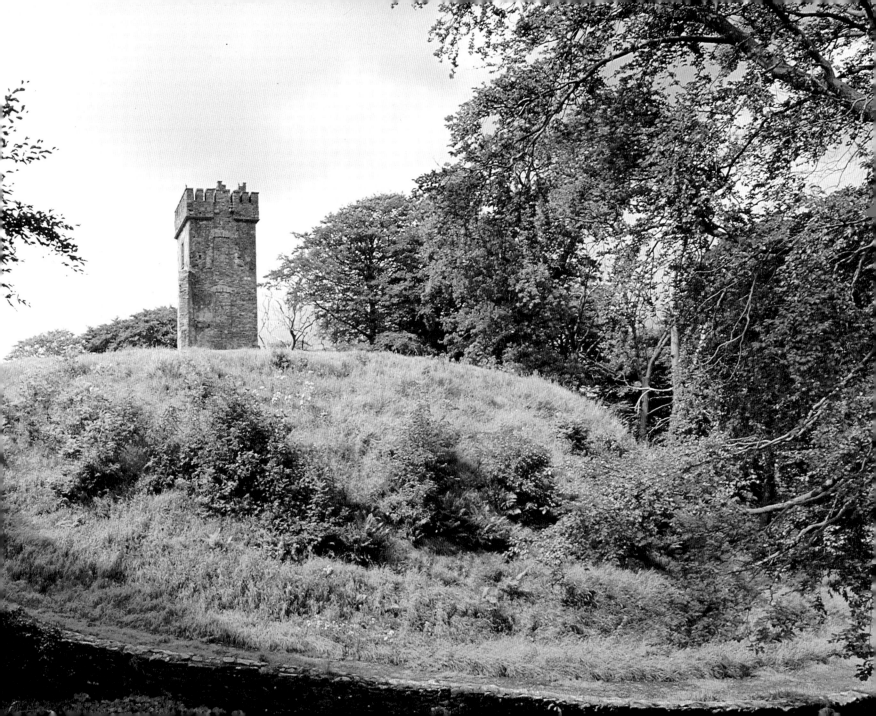

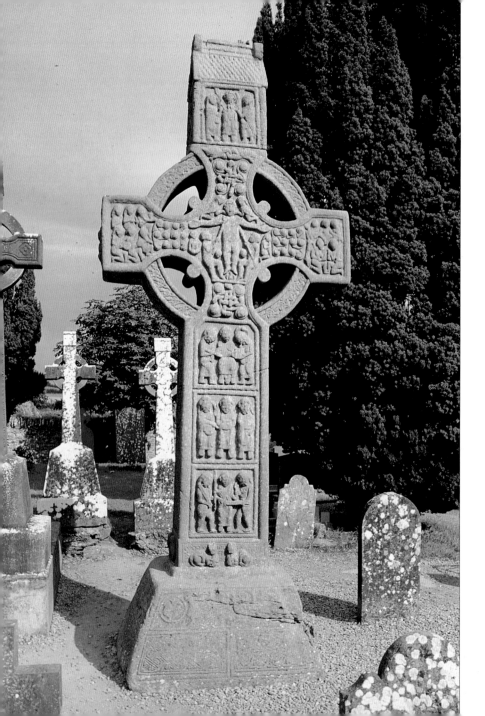

MUIREDACH'S CROSS, MONASTERBOICE, CO. LOUTH

Left: THIS IS ONE OF THE MOST ORNATE OF the later Celtic crosses. An inscription on the base invites the reader to 'pray for Muiredach, by whom this cross was made'. Almost certainly, this refers to the important local figure who was abbot of Monasterboice from 887 until his death in 923, and who also held the post of vice-abbot of Armagh. The biblical scenes portrayed on the monument served a practical, didactic purpose, as crosses of this kind were often the focus of open-air prayer meetings. For example, Doubting Thomas and the Arrest of Christ appear here on the shaft, while the Crucifixion is depicted within the wheel. Masons also liked to add lighthearted touches. The image of the beard-tuggers (right), which is featured on the side of the cross, was borrowed from contemporary manuscripts. There, the bodies of the men would be flattened out into ribbon-like forms and used in interlacing patterns. The length of the beards could be prodigious, and arms, legs and hair could also be interwoven. Monasterboice is on a ley line, which also takes in Tara and Knowth.

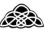

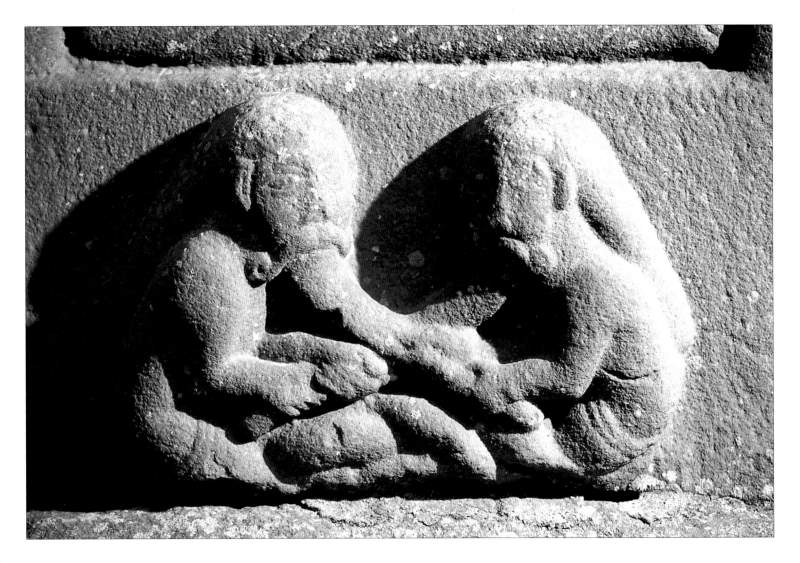

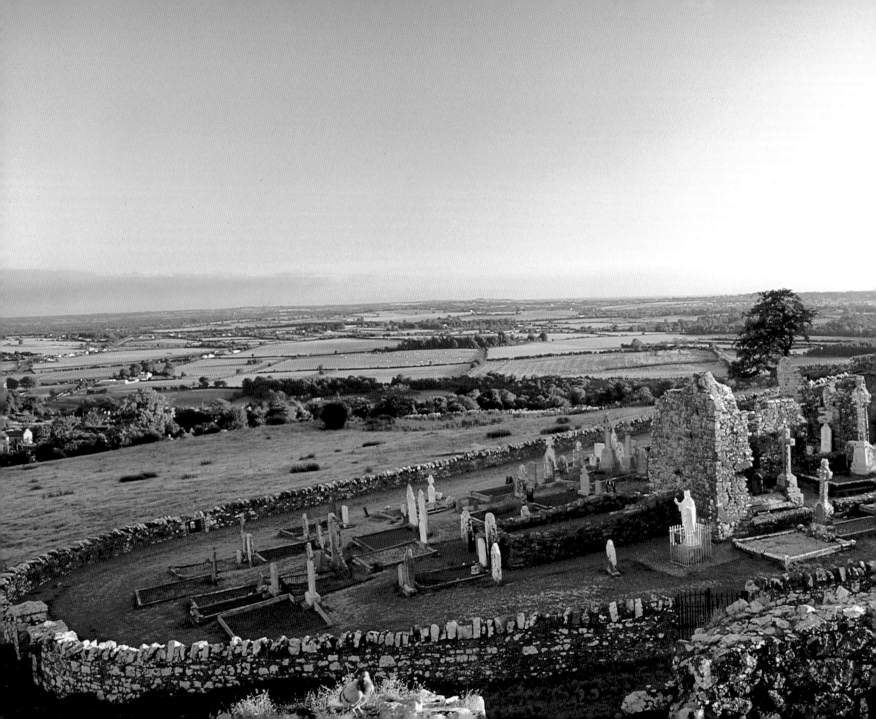

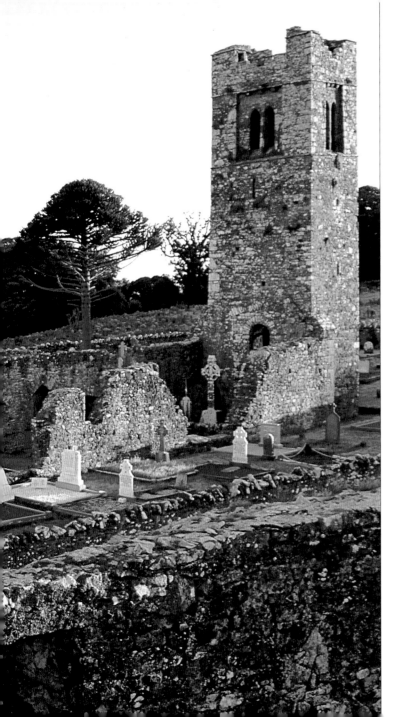

HILL OF SLANE, CO. MEATH

Left: THE REMAINS OF A 16th-century friary now stand
on the site where, by tradition, St Patrick first threw
down the gauntlet to the forces of paganism. On Easter
Saturday in 432, there was a heathen festival at nearby
Tara. At its climax, when the druids were due to light a
ceremonial bonfire, Patrick pre-empted them by kindling
his own fire on the Hill of Slane. The druids and the
high king were horrified at this, for it fulfilled a
longstanding prophecy that the keeper of a rival flame
would come to Tara and eclipse their power for ever.

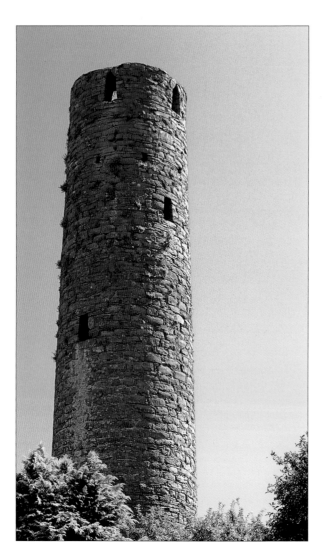

TRIM CASTLE & THE ROUND TOWER, KELLS, CO. MEATH

Left: INITIALLY, ROUND TOWERS in early Ireland were simple belltowers, calling the monks into prayer from their work in the fields. During the Viking period, however, they proved invaluable as look-out posts and treasure stores. This accounts for their high entrance points and for the fact that they were built out of stone, rather than timber. The monks of Kells had good reason for constructing such a tower, as their monastery was looted no fewer than six times in the 10th century.

Right: TRIM'S RISE TO prominence followed the success of a preacher named Loman, who converted the local chieftain and was granted land to build a church. By tradition, this achievement was intimately connected with St Patrick's mission, for the chieftain in question was Feidlimid, the son of Loegaire of Tara, while Loman was the saint's nephew. Later, Trim assumed great strategic importance and its castle became one of the principal strongholds of the English Pale. Doubts have been raised about its defensive capabilities, but it was deemed secure enough to host several Anglo-Norman parliaments.

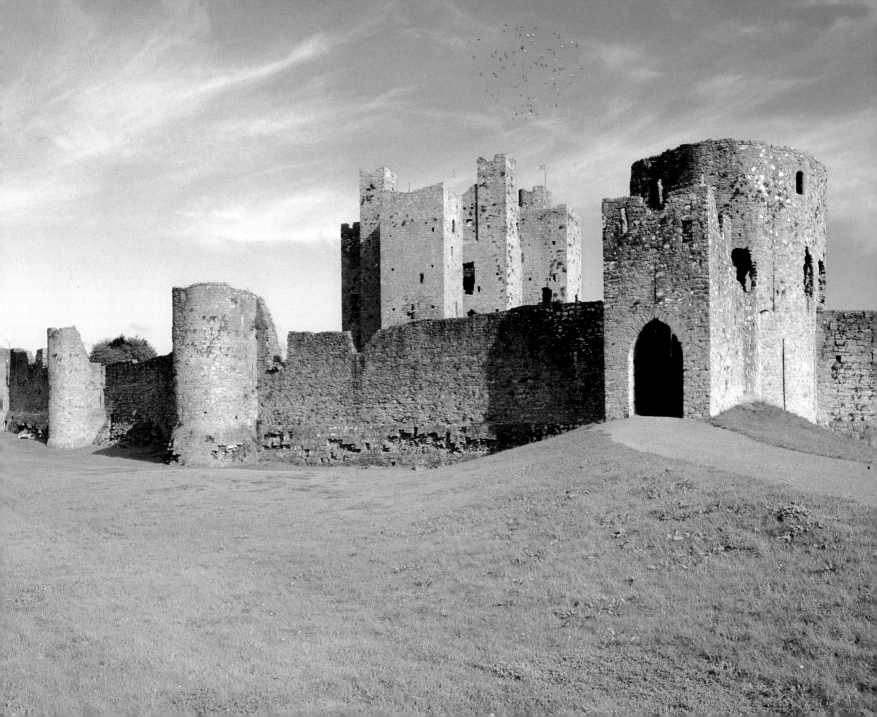

MELLIFONT ABBEY, CO. LOUTH

Right: MELLIFONT ABBEY, CO. LOUTH, was the first Cistercian house to be built in Ireland. It was the brainchild of St Malachy, a reforming cleric and former archbishop of Armagh, who founded it in 1142 on land donated by a local chieftain, Donagh O'Carroll. Further financial support came from King Muirchertach Mac Loughlainn, who endowed the abbey with 160 cows and 1.7 kg (60 ounces) of gold. Malachy was inspired by his meetings with the leader of the Cistercian order, St Bernard of Clairvaux, who sent an architect named Robert to supervise the project.

The finished buildings – remarkable though they must have been – were close to English and Continental models, signalling the decline of native Irish styles. Among the surviving features are a pseudo-crypt, designed to prevent flooding from the river; part of the octagonal lavabo, where the monks used to wash themselves in a fountain; and the delicate encaustic tiles from the abbey church now set into the floor of the 14th-century chapter-house (below). After its suppression in 1539 Mellifont was turned into a stronghold; William of Orange used it as his base during the Battle of the Boyne.

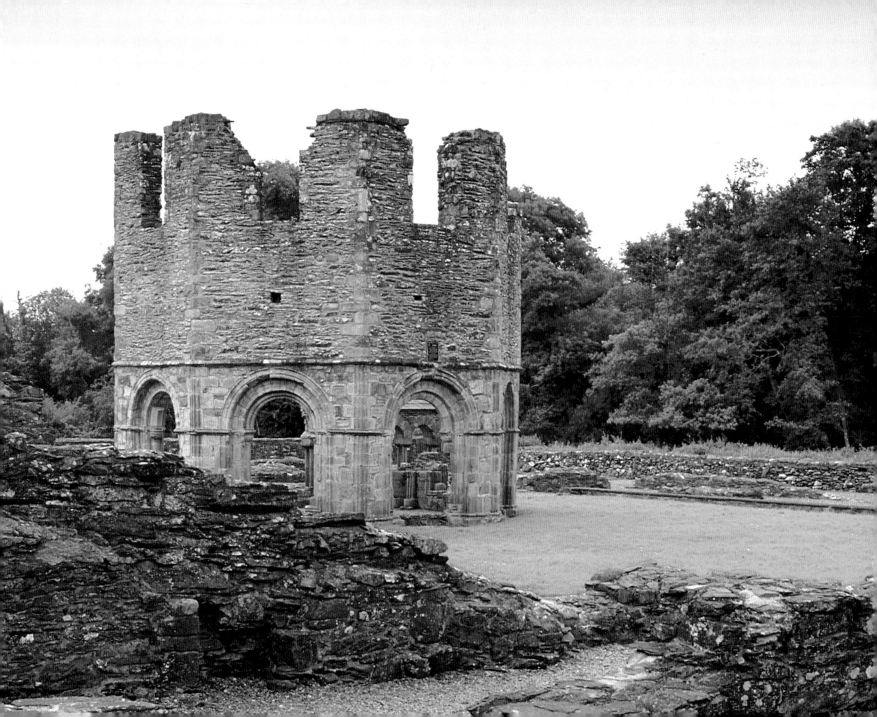

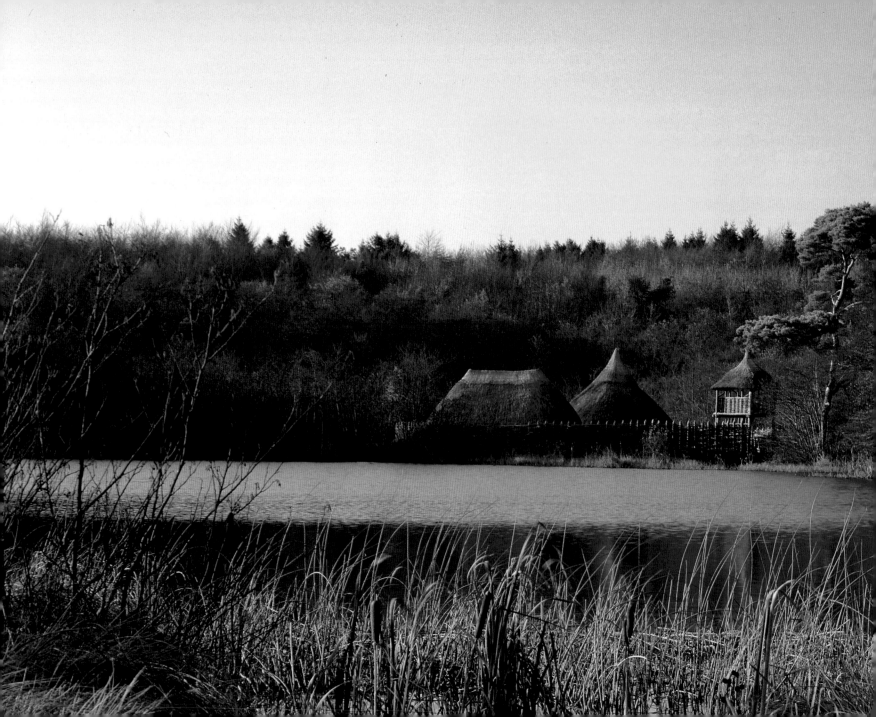

THE KINGDOM OF
MUNSTER

THE ANCIENT NAME for Munster was Mumu or Mumhan, thought to derive from the name of an early ruler, King Eocho Mumho. In common with Ulster and Leinster, the suffix '-ster' is of Viking origin. Legend describes it as a place of mystery, connected with the Otherworld. The sinister gathering place of the dead, Tech Duinn (House of Donn, the god of death) was supposedly situated on an island close to Munster's shores.

The first identifiable tribes belonged to the Erainn people, who were led by the petty kings of west Kerry. From an early point in the historic period, however, the dominant force in the area was the Eoghanacht dynasty. Very little is known about Eoghan, the founder of the clan, although some of

LEFT CRAGGAUNOWEN, CO. CLARE

Reconstruction of a crannóg, a fortified lake-dwelling. This constitutes part of the 'Living Past' project, set up in the grounds of Craggaunowen Castle.

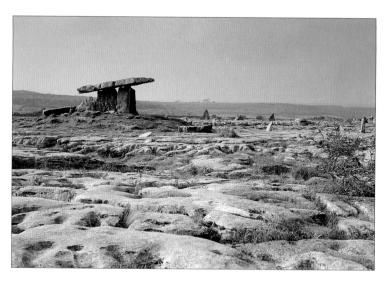

LEFT POULNABRONE, CO. CLARE

The prehistoric tomb of Poulnabrone, a portal dolmen set on the Burren's spectacular limestone plateau. The Burren takes its name from boireann, a Gaelic word for 'rocky land'.

According to the annals, the Eoghanacht established themselves at Cashel (see p. 139) during the reign of Oenghus. He became king there in the mid-5th century, with both pagan and Christian sources claiming the credit for his success. The former attributed his victories to the support of a druid named Boinda while, in the *Tripartite Life of St Patrick*, it was the king's decision to become baptized which was deemed crucial.

There is no firm proof that St Patrick himself ever came to Cashel, but the traditional links with the place are of great antiquity, and the towering base of the fortress has long been known as St Patrick's Rock. In addition, the meagre information that is available on the missions in Ireland before the arrival of St Patrick suggests that their efforts were concentrated in the south. In Munster, the leading figure was St Ailbe. Virtually nothing is known about the saint, apart from a series of colourful legends. According to these, he was suckled by a she-wolf and eventually retired to the fabled Land of Promise, a variant of the Celtic Otherworld.

In reality, his two main achievements were the foundation of a church at Emly – the most important Christian site in Munster, before the rise of Cashel – and the procurement of land on the Aran Isles from King Oenghus, where St Enda established his monastery.

the annalists relate that his real name was Mug Nuadat, and that he and another leader divided Ireland between them; southern Ireland was popularly known as Mug's Half.

A more popular myth attributed the success of the Eoghanacht to Conall Corc, one of Eoghan's descendants. He had a British mother and returned to Ireland, so it was said, after a period of exile in 'Pictland'. The latter may refer to Wales rather than Scotland however, for it is known that a group of Irish settlers was expelled from the Welsh coast in *c.* 400 AD. Conall's initial power base was small, but his people managed to extend their influence rapidly, mainly through judicious alliances with certain Erainn tribes and the dwindling power of the Laigin tribe in neighbouring Leinster.

Throughout the early Christian period, Munster became a favourite destination for those holy men who wished to lead the solitary life. The most famous of their settlements can be seen on the tiny island of Great Skellig, probably begun by St Finan in the 7th century. The province also has strong associations with St Brendan (484–577), one of the most renowned of all the Irish monks. He founded a monastery at Ardfert and is also linked with a reclusive site on Brandon Mountain, in the Dingle peninsula (see p. 122).

Cashel, meanwhile, remained the political focus. For much of the early historic era there was intense rivalry between branches of the Eoghanacht for the title of king. In this sense, Cashel was the southern equivalent of Tara, the seat of the high kings. Despite these inter-tribal squabbles Munster was probably the most peaceful of the Irish provinces. Comparatively few of its ancient rulers met with a violent death, and there are signs that it developed the most sophisticated culture. Plentiful inscriptions in ogham, an ancient form of writing, confirm a flourishing aristocratic caste, and the earliest written examples of Irish poetry were produced here in the late 6th century. Some argue that Munster's contacts with Gaul helped to maintain its superiority in this field.

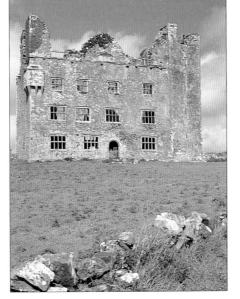

Many of these advances were swept away when Munster fell prey to Viking marauders. Their first attack took place in 795, and for more than a century southern Ireland suffered greatly at their hands. Effective resistance did not arrive until the Eoghanacht were supplanted by a new dynasty, the Dál Chais. Led by two brothers, Mahon and Brian Boru, these people took Cashel in 963 and inflicted a crushing defeat on the Norsemen at Sollohod. Brian Boru went on to even greater fame, winning another decisive victory at Clontarf in 1014. This proved a major turning point in the struggle against the Vikings, although it cost Brian Boru his life.

With the onset of the Middle Ages, the political geography of Munster changed. In place of the rivalry between east and west, the principal divisions were now between Thomond (the north-west) and Desmond (the south). Here, the leading families were, respectively, the O'Briens and the Mac Carthys. The former were the successors of Brian Boru, while the latter were the descendants of the Eoghanacht.

LEFT LEAMANEH CASTLE, CO. CLARE

Leamaneh Castle was built in 1643 by Conor O'Brien, a descendant of Brian Boru. Conor's wife was Máire Rua (Red Mary), who, according to one story, offered to marry any Cromwellian officer in order to prevent its confiscation.

OGHAM STONE, MAUMANORIG ENCLOSURE, CO. KERRY

Below: THE ANCIENT OGHAM alphabet takes its name from Ogma, the Celtic god of eloquence. Individual letters were composed of straight or slanting lines, notched onto the edges of stones and pillars. The system appears to have originated in south-west Ireland, reaching the peak of its popularity in the 5th and 6th centuries. Since this coincided precisely with the early Christian missions, it is not surprising that many of the stones were Christianized with the addition of a cross.

STAIGUE FORT, CO. KERRY

Right: SITUATED IN A commanding position in the Ring of Kerry, Staigue is one of the most impressive prehistoric hillforts in the country. Its internal diameter is 23.8 metres (78 feet) wide, and the surviving walls rise to a height of 5.2 metres (17 feet) in places. Although its main purpose would have been defense, there is a theory that Staigue Fort was sometimes used as a refuge for pilgrims travelling to Skellig Michael, a small island near the west coast which is visible from the fort.

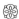

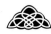

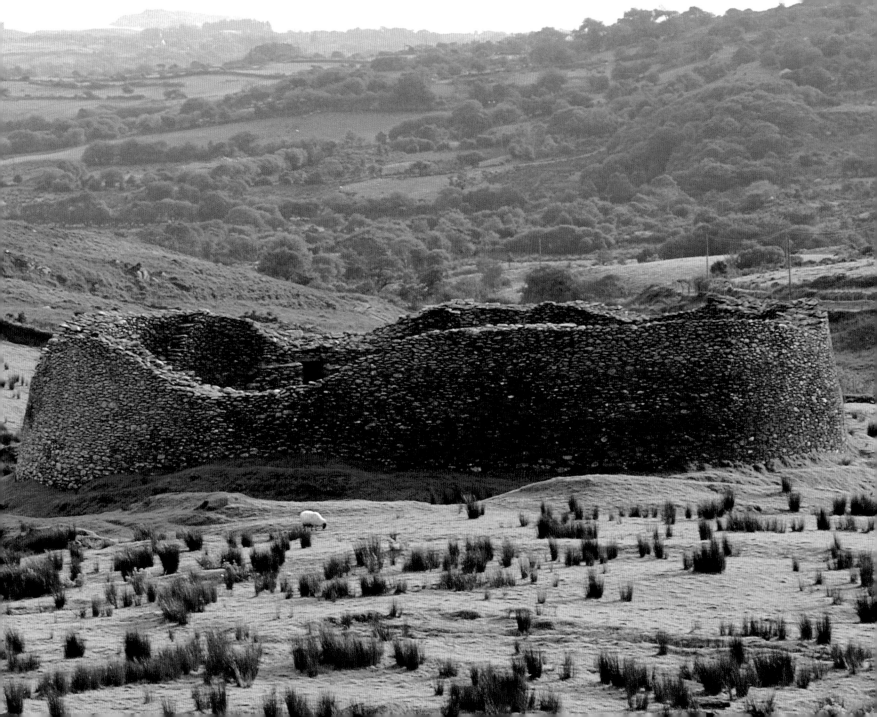

STAIGUE FORT, CO. KERRY

Right: STAIGUE'S EXCELLENT STATE of preservation offers intriguing evidence about the purpose and construction of ancient ringforts. Its walls are 3.9 metres (13 feet) thick and they incline slightly inwards, making life more difficult for potential attackers. Access to the upper parts of the wall could be gained through a system of internal stairways. In addition, two small passages set into the walls would have offered the same kind of protection as a souterrain (see p. 62). There has been much debate as to whether ringforts were genuine military structures or simply fortified farmsteads, capable only of keeping out wolves and petty thieves, but Staigue Fort was certainly the former.

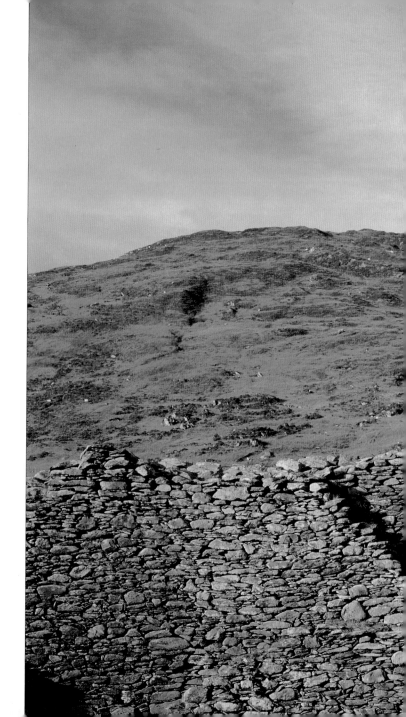

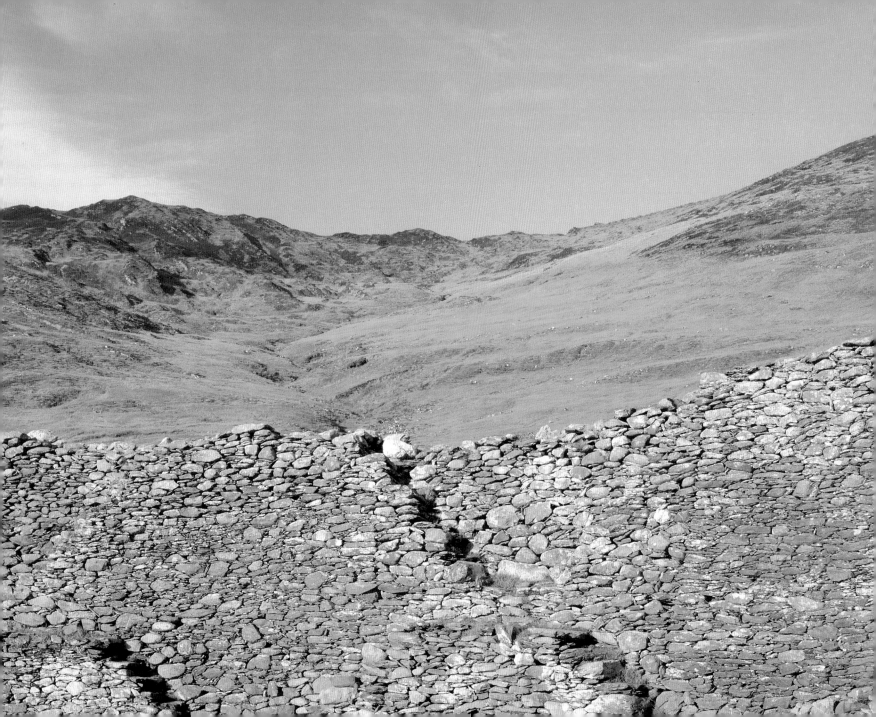

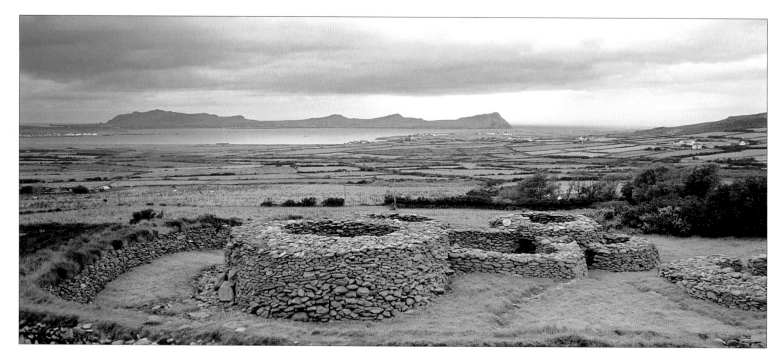

RINGFORT, CAHERDORGAN NORTH, CO. KERRY

Above: THE DWELLING-PLACES inside individual ringforts varied
according to the wealth of their occupants. Some were simple
post-and-wattle buildings, while others were sturdier, drystone huts.
The latter were particularly popular in western Ireland, as the
remains at Caherdorgan confirm. Huts of this kind were not
always fully corbelled, occasionally some had a roof of thatch
supported by a wooden post.

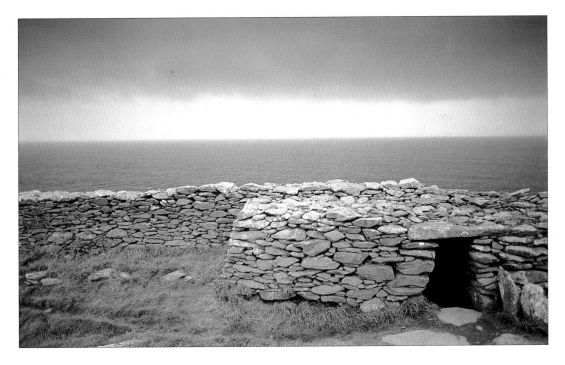

ENTRANCE, DUNBEG FORT, CO. KERRY

Above: BECAUSE PROMONTORY forts were virtually surrounded by the
sea, they offered a considerable degree of protection to their
inhabitants. Even so, the builders of Dunbeg Fort took no chances;
a series of banks and ditches, together with a thick stone rampart,
was erected in front of a single beehive hut. In addition, a souterrain
linked the rampart with the first row of ditches, therefore
increasing the fort's protection.

Upper Lake, Killarney, Co. Kerry

Right: THE WIND WHIPS UP around the shores of Killarney's lakes, evoking memories of the fairy people from the *sidhe*. Superstitious folk used to believe that the old gods travelled in the breeze so they blessed themselves whenever they saw a gust of wind whirling the leaves on a country path or shaking the reeds at the water's edge. Magic of another kind went on beneath the surface of the lake, where a chieftain called O'Donoghue held court, emerging each year at the festival of Beltane, a Celtic fire festival celebrated on May 1st.

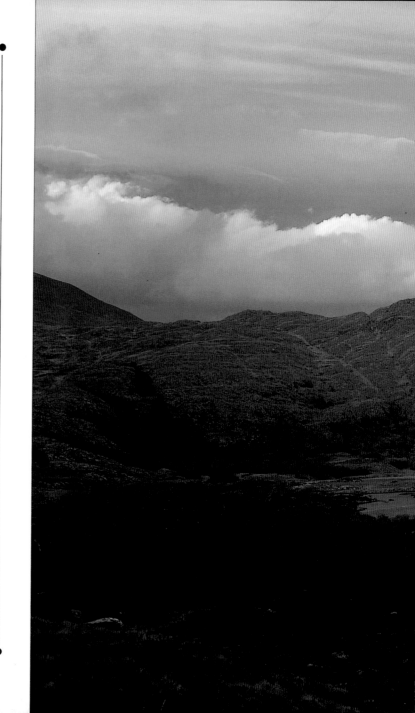

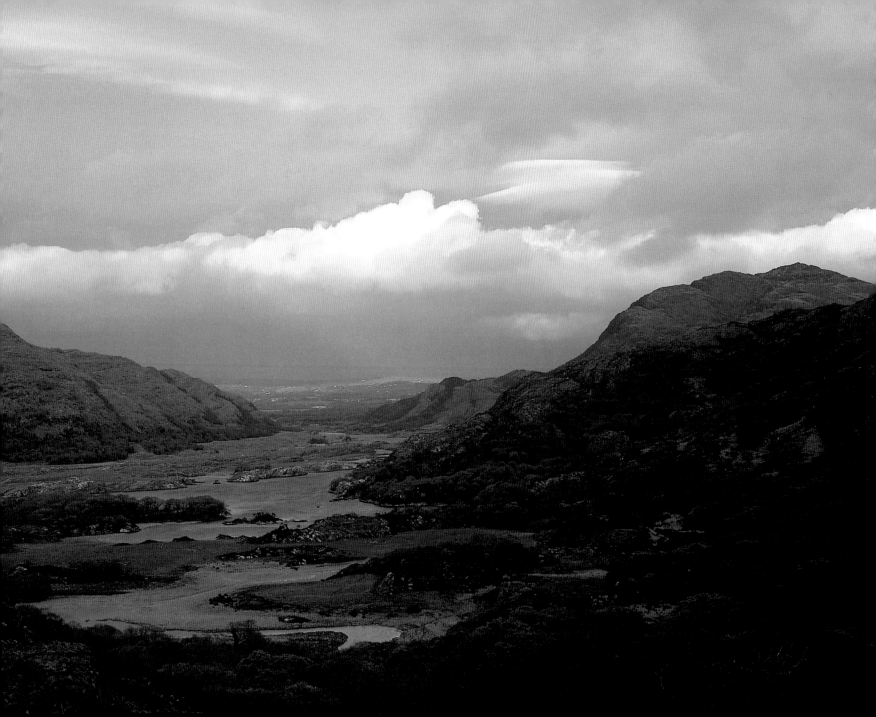

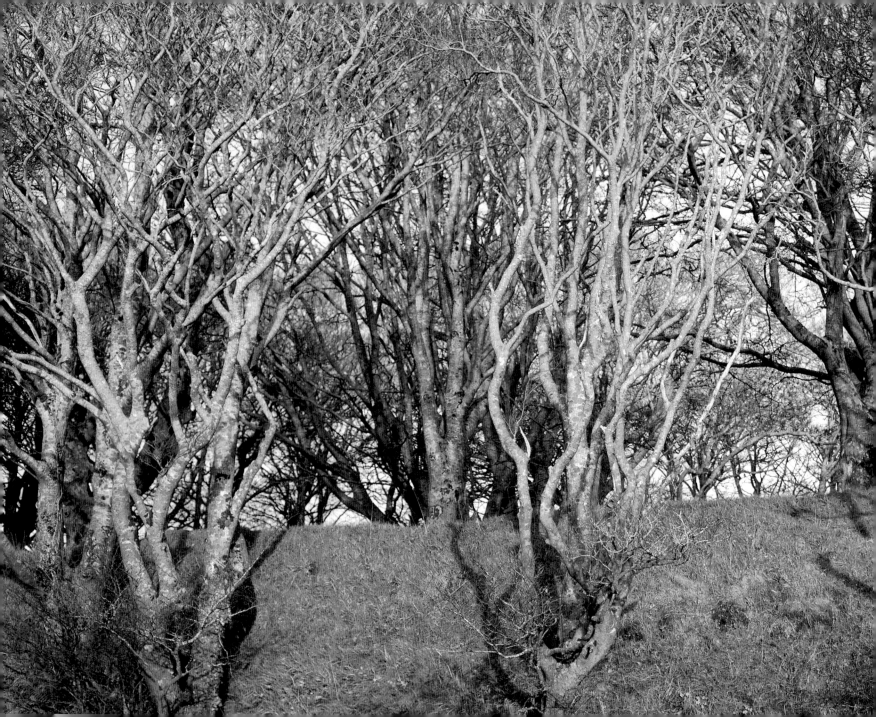

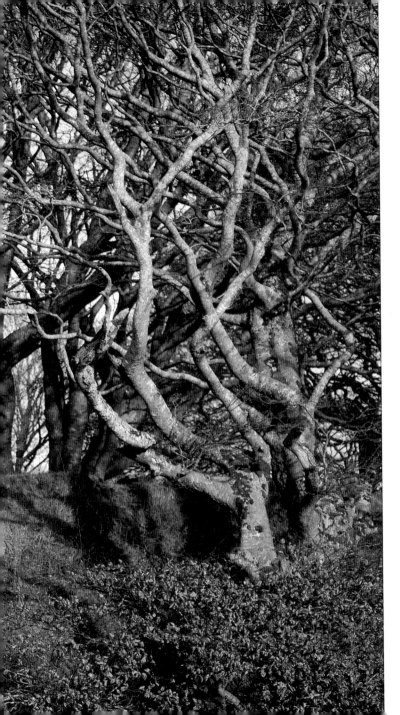

An Ráth, Co. Clare

Left: A RATH IS A TYPE of ringfort, formed out of earthen ramparts rather than a stone wall. Enclosures might be round, oval or pear-shaped, and the average diameter is around 30 metres (100 feet). Most raths have a single, circular rampart, though this example has two, separated by a ditch. In some cases, the central area was also heightened to form an artificial platform or mound. For obvious reasons, raths were most common in areas where stone was in short supply. They are often hard to detect, as the invading Anglo-Normans transformed many of them into mottes, the artificial hills on which castles were placed.

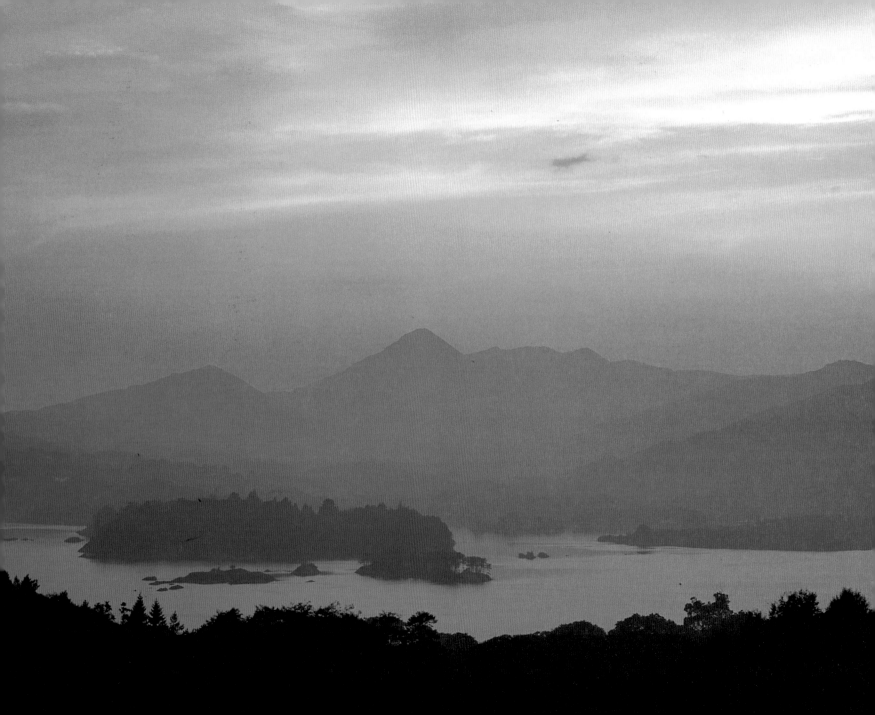

BANTRY BAY, CO. CORK

Left: ONE OF THE MOST arresting panoramic vistas of
ancient Ireland, Bantry was the traditional departure
point for Brendan the Navigator's voyages in the
Atlantic. Ostensibly, he was following the example
of other Irish monks, who used to venture out in
their coracles looking for their 'desert in the ocean'
where they could lead a penitential existence.
According to legend, Brendan's voyages took him
to a number of fabulous destinations, before he
eventually found his 'Land of Promise', and returned
home content. Some believe that this was a reference
to the Canaries, while others have speculated about a
pre-Viking voyage to America.

STONE CIRCLE, LOUGH GUR, CO. LIMERICK

Right: SITUATED AROUND THE shores of Lough Gur is the
richest concentration of prehistoric sites in Ireland. The
great stone circle, said to be the largest in the country, is
50 metres (150 feet) in diameter and is ringed with
earthworks that are 10 metres (30 feet) wide. It has a
paved entry passage, flanked by portal stones, and the
centre of the circle has been raised with a level of clay.
Other finds in the area include a group of neolithic huts,
some smaller stone circles, several cashels and graves,
and a crannóg, an ancient Celtic lake dwelling.

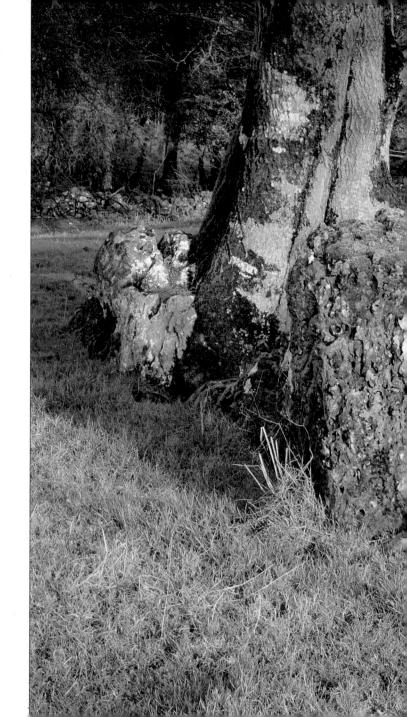

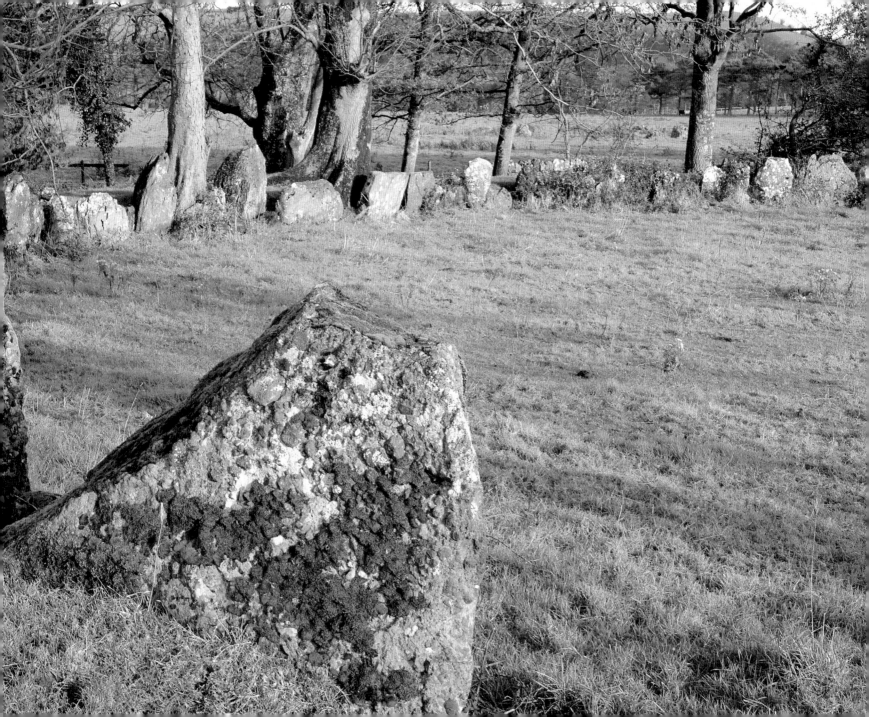

FAHAN BEEHIVE HUTS, DINGLE PENINSULA, CO. KERRY

BECAUSE OF THE abundance of rocks in the area, beehive huts were extremely common in south-western Ireland. More than 400 have been discovered in the Dingle peninsula alone, the best of these being in the 'village' of Fahan. The rows of stones were probably covered with clods of earth to offer some additional protection against the elements, and entrances were usually kept as small as possible. Beehive huts are hard to date, but they seem to have been most popular during the early Christian era.

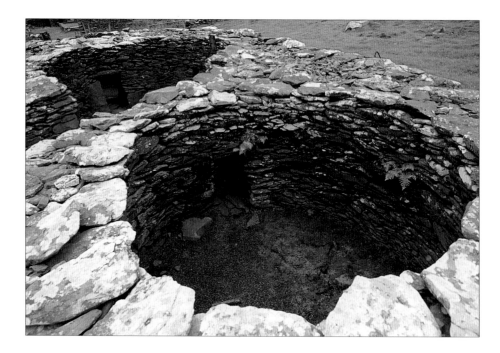

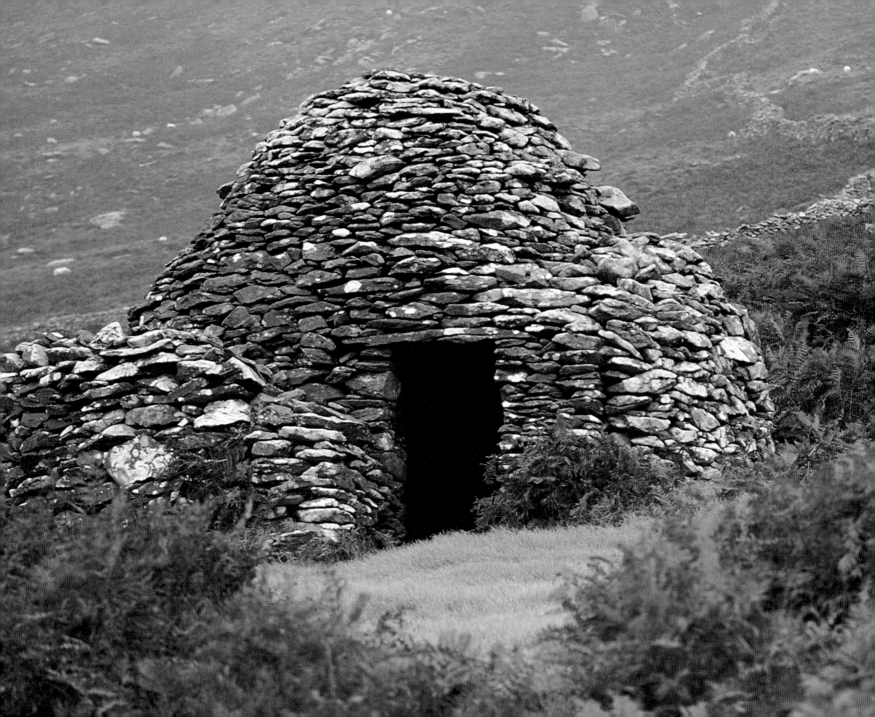

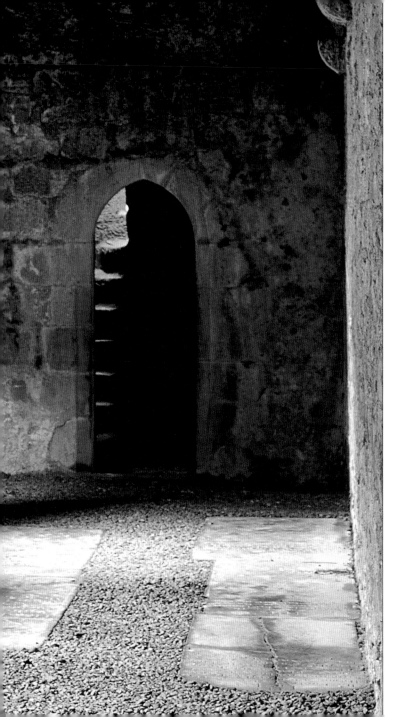

QUIN FRIARY, CO. CLARE

Left: MANY RELIGIOUS HOUSES were built on earlier
Christian foundations, but Quin's Franciscan friary has
the rare distinction of incorporating a secular site. This
was the Norman stronghold of Thomas de Clare, the
lord of Thomond, which had been pillaged in 1286.
The castle lay in ruins for 150 years until it was
granted to the friars by the Macnamaras in the
1430s. There are claims that Quin became the
first Observantine house in Ireland, following the
austere lifestyle led by their founder St Francis.

ADARE CASTLE, CO. LIMERICK

Right: SET PICTURESQUELY ON the banks of the river
Maigue, Adare Castle provides a telling example of
Norman feudal strength. Within a decade or so of their
arrival on Irish soil in the 1170s, the Anglo-Norman
adventurers began to cement their power by erecting a
series of impressive strongholds. Although the precise
details of its origin are unknown, Adare Castle probably
dates from the 1220s. It may have been built by the
O'Donovans or perhaps by Geoffrey de Marisco, who
owned a manor house there. Either way, Adare Castle is
now more closely associated with the earls of Desmond,
who held it in the 16th century.

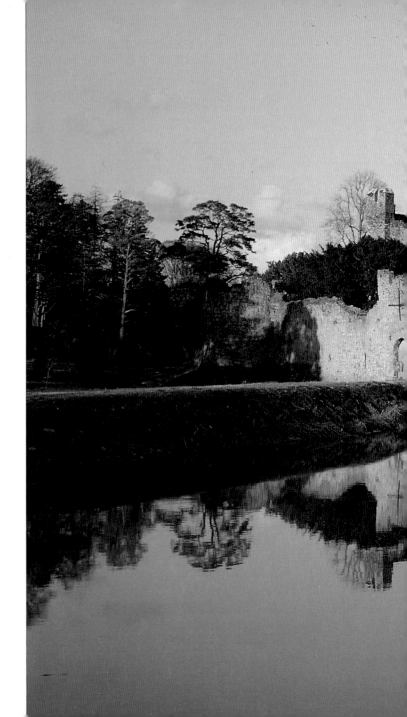

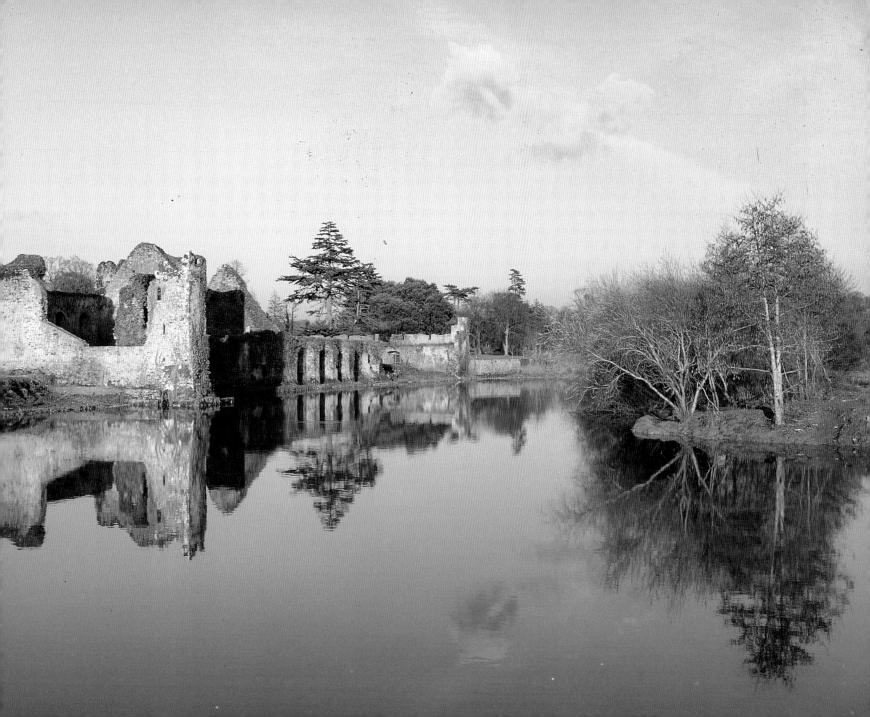

SHEILA-NA-GIG, KILLINABOY, CO. CLARE

Below: THE RUINED CHURCH at Killinaboy stands on the site of an ancient monastery, dedicated to St Inghean Bhaoth. Its most surprising feature is a tiny sheila-na-gig, fixed above the south door. The presence of this Irish fertility goddess, blatantly displaying her sexuality, provides clear evidence of the Church's willingness to placate its heathen rivals.

GALLARUS ORATORY, CO. KERRY

Right: WITH ITS DISTINCTIVE, boat-shaped appearance, Gallarus is certainly the most famous of the early Christian oratories. Its construction utilized the drystone roofing technique known as corbelling that had been pioneered by neolithic tomb-builders. The walls are 0.9 metres (3 feet) thick and the only concession to luxury is a tiny window, cut out of a single stone.

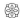

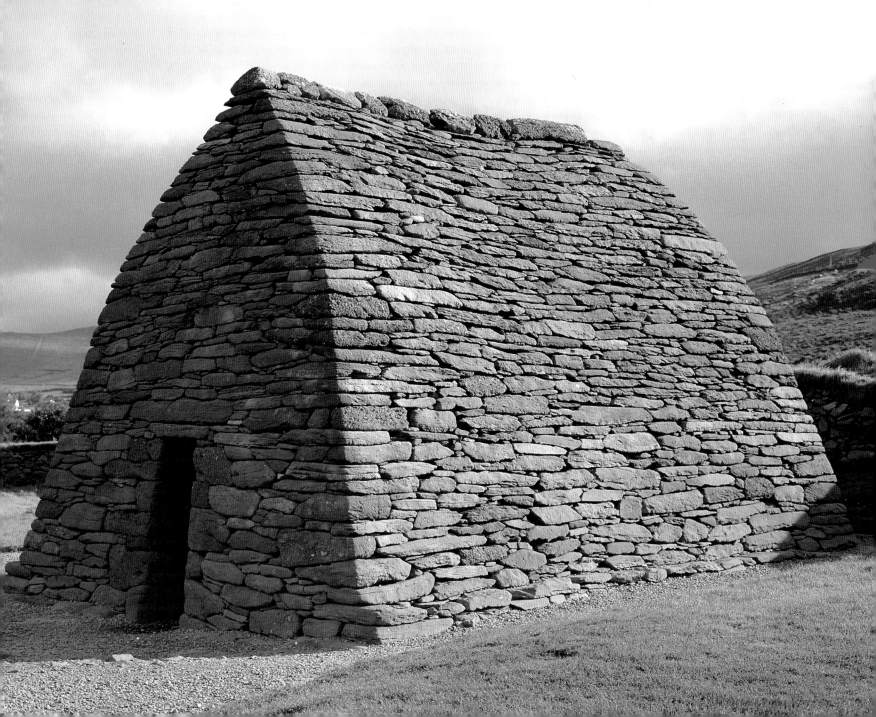

RAHINNANE CASTLE, CO. KERRY

Right: RAHINNANE CASTLE WAS built on the foundations of an ancient ringfort and souterrain. Its stumpy remains appear very battle-worn, which is apt, since one of the warrior-hero Finn Mac Cool's greatest victories took place at nearby Ventry. With typical gusto, the chronicler of these legendary feats told how the elements themselves reflected the conflict:

The earth trembled in foreboding at the terrible slaughter; the sun veiled itself in darkness before the clamour of the grey hosts; and the ravens, the wolf-packs, and the wild women of the glen shrieked together like demons, urging the warriors on in their bloody fray…

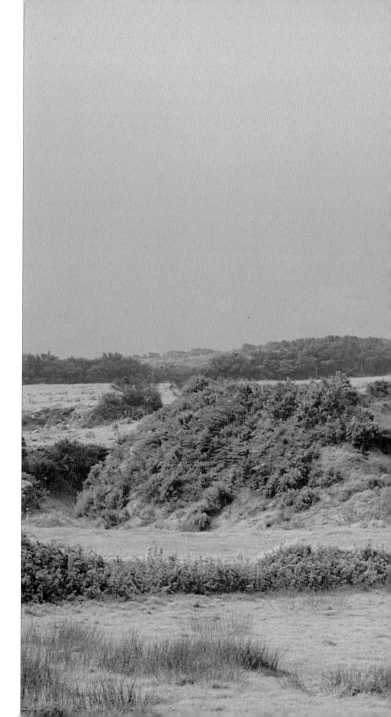

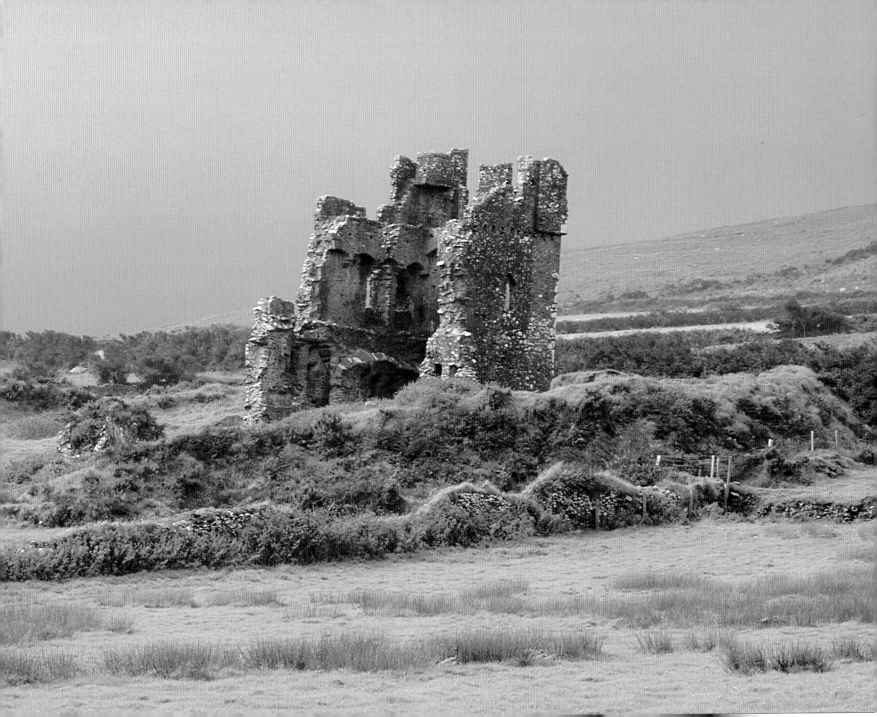

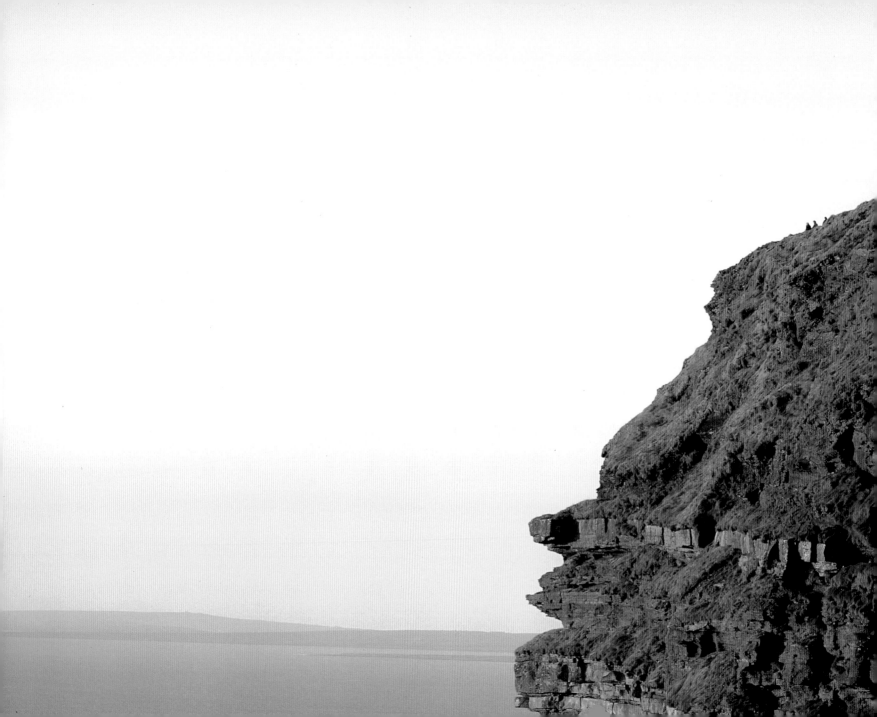

The Cliffs of Moher, Co. Clare

Left: Rising to a height of over 200 metres (650 feet) and extending for more than 8 kilometres (5 miles), the Cliffs of Moher form one of the most dramatic stretches of Ireland's coastline. The cliffs take their name from an ancient promontory fort called Mothair, which must have been almost impregnable, until it was removed a century ago to make way for a signalling tower. Not far away is St Brigid's Well, which used to be the focus of great celebrations at Lughnasadh, the Celtic summer festival, while further down the coast the legendary city of Cill Stuihín is said to lie submerged.

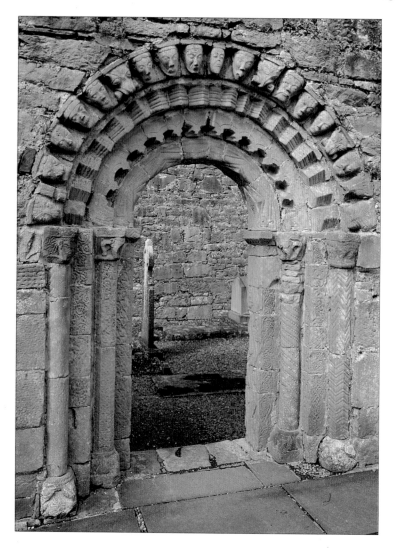

ROMANESQUE DOORWAY, DYSERT O'DEA, CO. CLARE

Left: DYSERT TAKES ITS NAME from the *dísert* or 'hermitage' of St Tola (d. 737), who also founded a church at Clonard. The church was restored in 1683 by Michael O'Dea, a descendant of the original landowners. Among other things, O'Dea reassembled this romanesque arch (detail, right), incorporating some of the stonework from the neighbouring church of Rath. Dysert was also the scene of an important battle in 1318, when Irish forces defeated Richard de Clare, thereby halting the Anglo-Norman advance into Thomond.

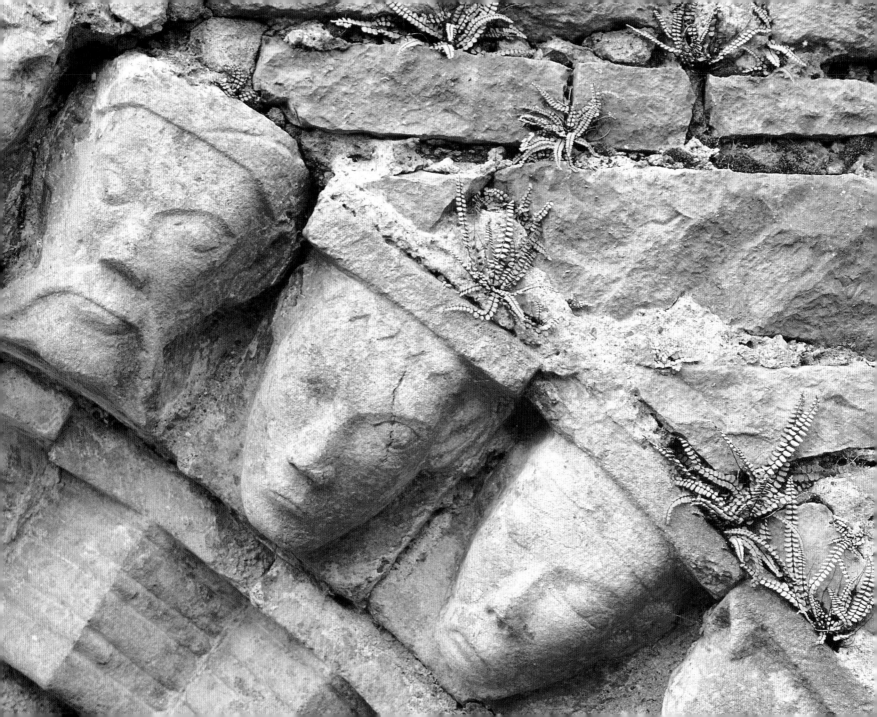

ABBEY RUINS, CASHEL, CO. TIPPERARY

Right: CASHEL IS SURROUNDED by castles and here,
within sight of St Patrick's rock, can be found the ruins
of Hore Abbey, a 13th-century Cistercian foundation.
Previously, there had been a Benedictine priory on this
site, but Archbishop Dáibhí Mac Cearbhaill expelled the
monks after dreaming that they were hatching a plot to
behead him. Close by, there are also the remains of a
Dominican friary. Known as St Dominic's Priory, this
was founded in 1243 by Archbishop Mac Ceallaigh.

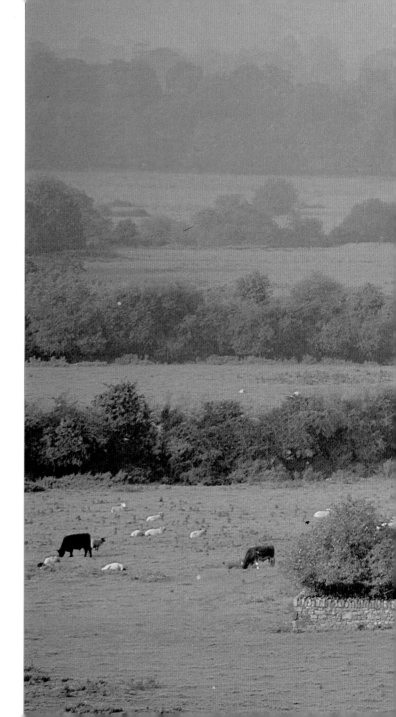

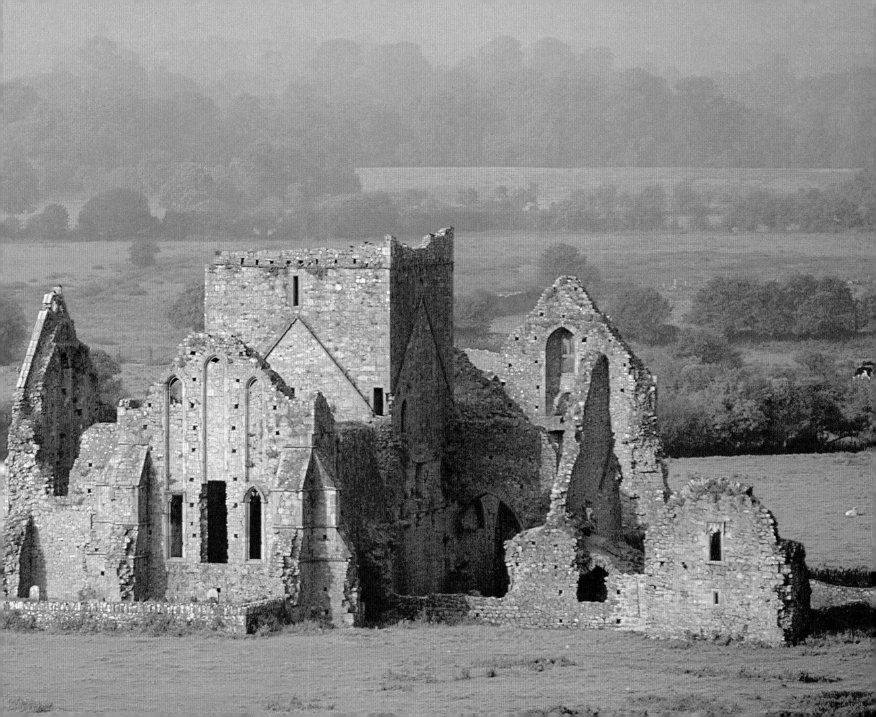

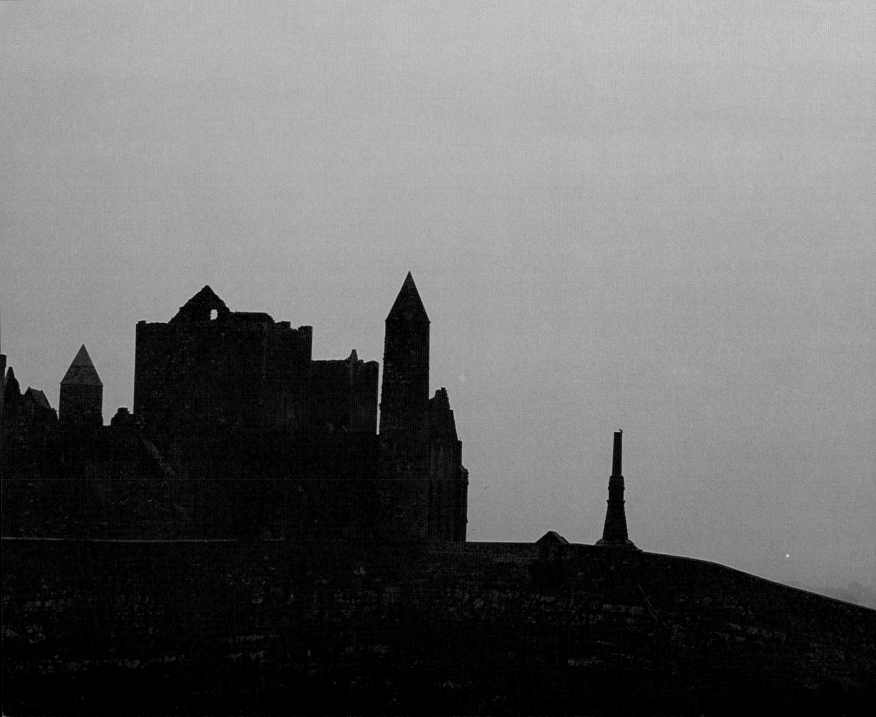

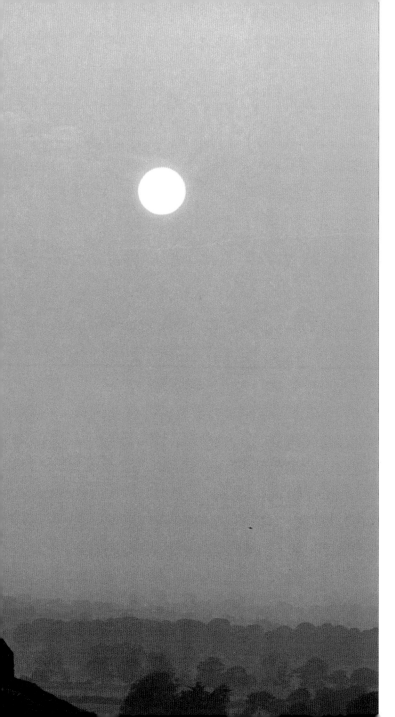

ROCK OF CASHEL, CO. TIPPERARY

Left: THE SILHOUETTE OF THE buildings on the Rock of
Cashel, also known as St Patrick's Rock, is one of the
most familiar sights in Ireland. Part fortress, part palace
and part church, Cashel belonged initially to the
Eoghanacht dynasty, the powerful kings who ruled over
the southern half of Ireland. Here, St Patrick converted
and baptized King Oenghus. During the ceremony, it is
said that he impaled the king's foot with the sharp point
of his crozier, but Oenghus bore this with fortitude,
believing it to be part of the ritual. Cashel acquired its
ecclesiastical character in 1101, when Muircheartach
O'Brien, ruler of Cashel, bestowed it on the Church,
expecting it to become the new see of Munster.

THE KINGDOM OF
LEINSTER

THE PROVINCE of Leinster used to be called Laigin, which was also the name of its ancient people. The source of this word is uncertain, although it is said to derive from the *laighne*, or spears, of the Gaulish warriors who lent assistance to Móen, a legendary prince of Leinster. Prince Móen had suffered cruel treatment at the hands of his uncle Cobhthach, who had killed the king and forced young Móen to eat his heart. However, the prince escaped to Gaul where he befriended a king of the Fir Morca people, who helped him regain his throne.

Early historical accounts suggest that the kingdom of Leinster was occupied by three waves of invaders, namely the Fir Domnann, the Gáileóin and the

LEFT: ST PATRICK'S CATHEDRAL, DUBLIN

The Choir Banners, symbolic swords and helmets of the Order of St Patrick. The saint is said to have called forth a well and baptized new converts on this site.

Laigin. The Fir Domnann were probably the first to arrive. They conquered large tracts of Ireland, leaving their mark on a number of place-names, such as Irrus Domnann (now Erris). They were succeeded by the Gáileóin, who may have been a race of British mercenaries, and finally the Laigin. The origins of the latter are disputed, although it is possible that they came from the Lleyn peninsula in north Wales. In any event, they were the only invaders to survive into the historic period.

Prior to this, Leinster was associated with the legend of Finn Mac Cool, Ireland's legendary warrior-hero. Finn's stronghold was at the Hill of Allen (Almain), a few miles from Kildare. Archaeologists believe that this may have been the site of a prehistoric tumulus, which could explain why early storytellers

chose to link the place with a legendary character. The hill was surrounded by dense bogland – on some 18th-century maps it was described as the Isle of Allen – and this ties in well with the ancient tales of Finn, which describe his homeland as a remote, marshy wilderness.

In the course of his adventures Finn travelled to the sacred site of Tara, where he enlisted in the service of the high king, Cormac Mac Art, and took command of his royal bodyguard, known as the Fianna. Finn's exploits with this noble body of knights are often reminiscent of the deeds of King Arthur. Indeed, in the episode of Diarmaid and Gráinne (see pp. 20–21, 86–87) there is even a striking parallel with the inconstancy of Queen Guinevere.

At the same time, Leinster's fabled involvement with Tara echoes the province's historical development. The Laigin's principal neighbours were the Osraige (deer-people) to the west and Meath to the north. In time, the Osraige tribe formed the kingdom of Ossory, which acted as a convenient buffer-zone between Leinster and Munster. Instead the Laigin chiefs turned their attention towards the north, competing with the southern Uí Néill tribe for the possession of Tara. This bitter rivalry lasted until the arrival of the Vikings, resulting, more often than not, in defeat for the Laigin.

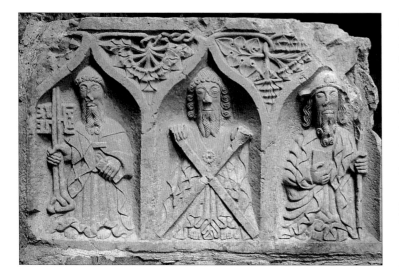

LEFT: JERPOINT ABBEY, CO. KILKENNY

This 16th-century tomb portrays three of the apostles with their attributes. St Peter holds a key, St Andrew is shown with a saltire cross, and St James bears a scallop shell and staff, the traditional symbols of a pilgrim.

The best-documented of the early conflicts concerned Loegaire, the high king who clashed with St Patrick on the Hill of Slane (see pp. 98–99). He triumphed over the Laigin in 452 and 453, but was defeated at the battle of Ath Dara five years later. When he died his people obeyed his wishes and buried him in an upright position, facing his enemy to the south. Loegaire's defeat, however, proved to be just a temporary setback for the Uí Néill. Resounding victories at Croghan Hill (475), Teltown (494) and Druim Derge (516) turned the tide, penning the Laigin back into the south-east corner of the country for generations to come.

During the early Christian period Leinster figured prominently in the spread of the monastic movement. In Clonmacnois, Glendalough and Durrow, it possessed three of the most influential foundations of the time. It could also boast of having Ireland's second most famous saint after St Patrick; this was St Brigid (c. 450–c. 523), the abbess of Kildare, who had earned the nickname 'Mary of the Gaels' after receiving a vision of the Virgin. Details of her life are shadowy, and early accounts suggest that she became associated with the pagan traditions of a Celtic goddess, also called Brigid. The saint's feast-day was celebrated on February 1st, the same day as the festival of Imbolc, dedicated to the goddess. Equally, there were

LEFT: BROWNESHILL DOLMEN, CO. CARLOW

The tightly wedged supporting stones failed to prevent Browneshill's gigantic capstone from slipping backwards. Estimated at 100 tons, it is by far the heaviest in Ireland.

certainly pagan overtones in the perpetual fire that was tended at Kildare, set in a circular enclosure which was forbidden to all men.

Kildare was sacked by the Vikings in 835, a fate that was shared by many other churches in Leinster. It seems that the province suffered greater devastation than its neighbours, and it was here that the raiders first attempted to create permanent settlements. Dublin, Waterford and Wexford all owe their origins to this policy. In the case of Dublin, the process began in 841 when the Norsemen constructed their first homesteads by the river Liffey. Norse reinforcements arrived a decade later and by 871 the tiny kingdom of Dublinshire was firmly established as a base for trading and making inland raids.

The attitude of the Leinster kings towards these foreign settlements was equivocal. Occasionally, Leinster and Dublin formed alliances in order to challenge the growing strength of Munster. However these pacts were overturned when the Munster leader, Brian Boru, embarked upon his triumphant campaigns against the invaders, which culminated in the decisive victory at Clontarf in 1014.

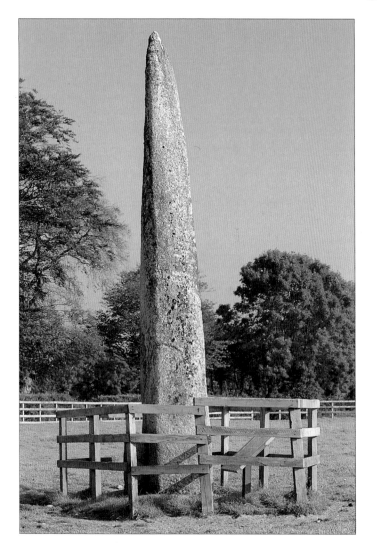

PUNCHESTOWN STANDING STONE, CO. KILDARE

Left: THERE HAS BEEN a great deal of speculation about the purpose of single standing stones. Some people believe that they were erected at the burial sites of ancient chieftains; others that they were designed to mark territorial boundaries or major routes. There is even a theory that they were meant to help cattle scratch themselves. In the case of the Punchestown monolith, this question was answered in 1934, when the stone was repositioned and a cist (a chest-like tomb) was revealed. Its occupant must surely have been important, for the 7-metre (23-foot) monument is the tallest in Ireland.

BROWNESHILL DOLMEN, CO. CARLOW

Right: PORTAL DOLMENS ARE perhaps the most impressive of the megalithic chamber tombs. It required considerable technical skill and manpower to transport the stones using a system of rollers and then to arrange them in such precarious formations. Nowhere would these problems have been more evident than at Browneshill, where the mighty capstone weighs 101,600 kg (100 tons), easily the heaviest example in Ireland. As a result, two of the supporting uprights have collapsed and the rear section now slopes down to the ground.

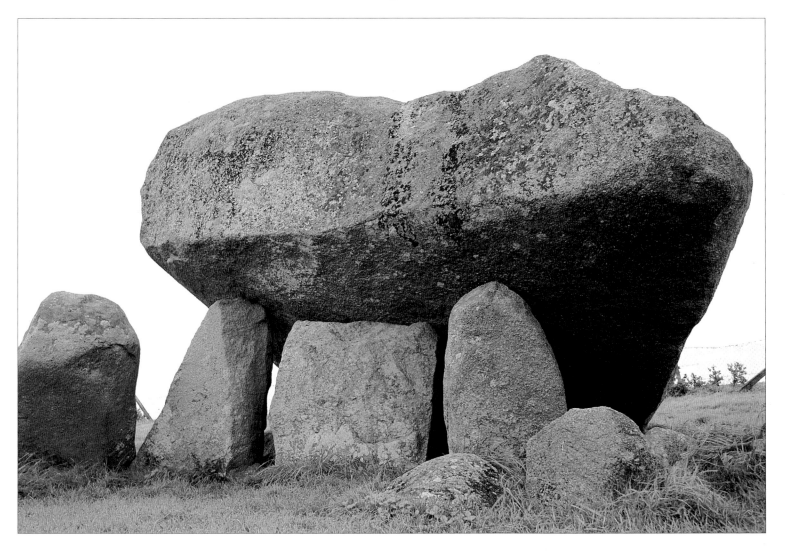

Dunbrody Abbey, Co. Wexford

Right: The imposing ruins of Dunbrody Abbey are a testament to the growth of foreign influences in Ireland. The land was donated in 1178 by Hervey de Montmorency, the uncle and seneschal of Strongbow, the best-known of the Anglo-Norman adventurers. The original recipient was a Cistercian abbey in Shropshire, which rapidly passed on the gift to St Mary's Abbey in Dublin, after hearing reports about the barrenness of the land and the 'wildness and ferocity of the local barbarians'. Unwittingly, Hervey may have helped to reinforce this image by stipulating that outlaws were to be granted asylum at his church. As a result, it soon earned the nickname of St Mary of Refuge. Most of the abbey was constructed in the early years of the 13th century, in the austere style that was typical of continental, Cistercian architecture.

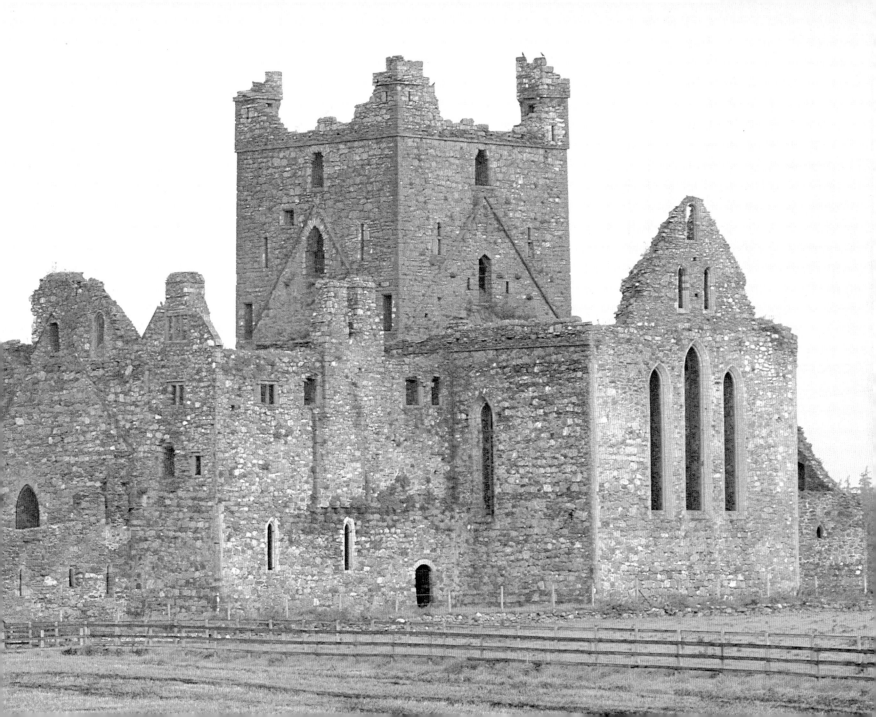

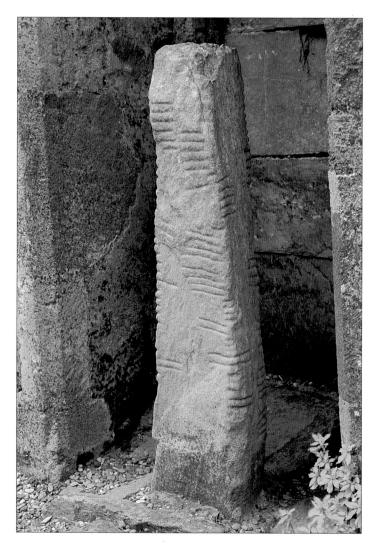

OGHAM STONE, ARDMORE CHURCH, CO. WATERFORD

Left: OGHAM WAS THE earliest form of writing known in Ireland. The druids employed it for incantations, and some inscriptions have survived on tomb-markers. Because of their heathen associations, however, such stones were usually destroyed or Christianized by missionaries – and this is what happened here. The original inscription is thought to refer to 'Lugaid, descendant of Nia Segamain', one of the early pagan kings, but at a later stage, a suffragan bishop named Dolatus had his own name added, thereby conferring upon the stone an air of Christian respectability.

ARDMORE CHURCH, CO. WATERFORD

Right: ARDMORE'S REMARKABLE church was founded by St Declan, one of the four 5th-century missionaries said to have preached in Ireland before the arrival of St Patrick. According to a local tradition, Declan's handbell and vestments floated across the Irish Sea on a boulder, which came to rest on Ardmore's beach. Among the subjects portrayed are the Fall, the Judgment of Solomon, and the Adoration of the Magi.

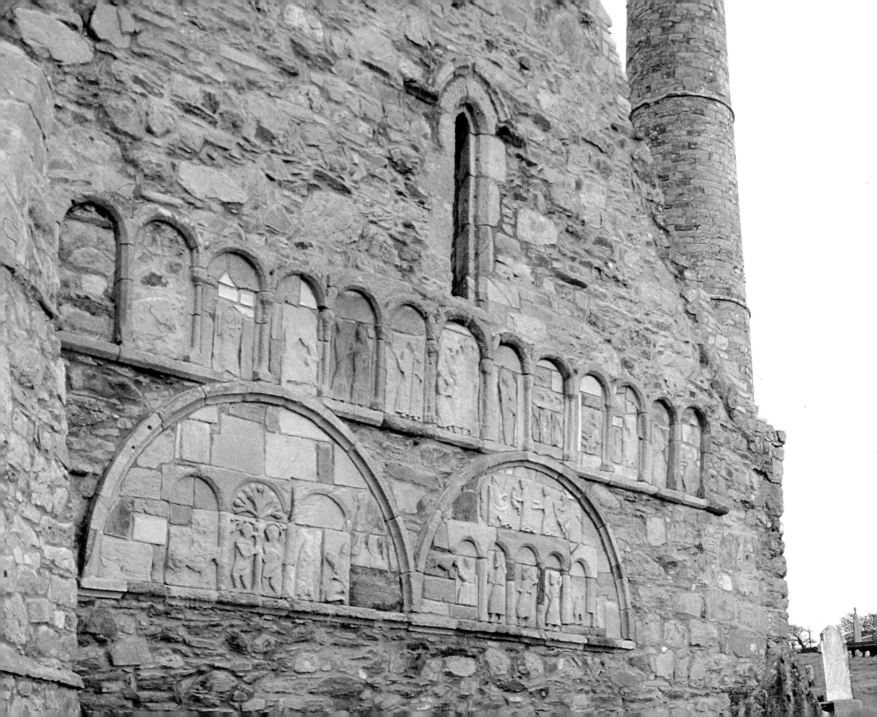

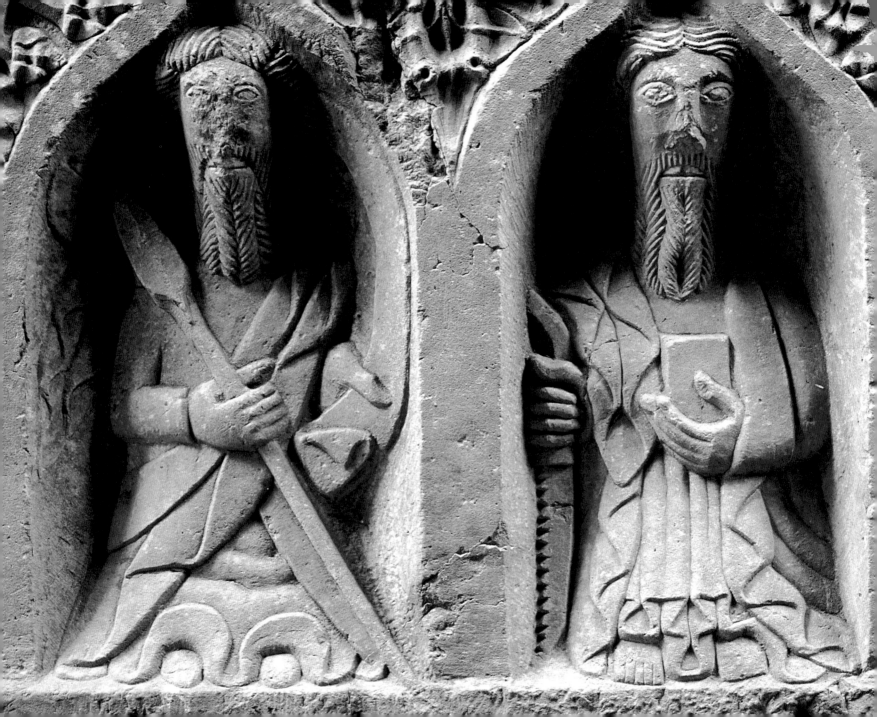

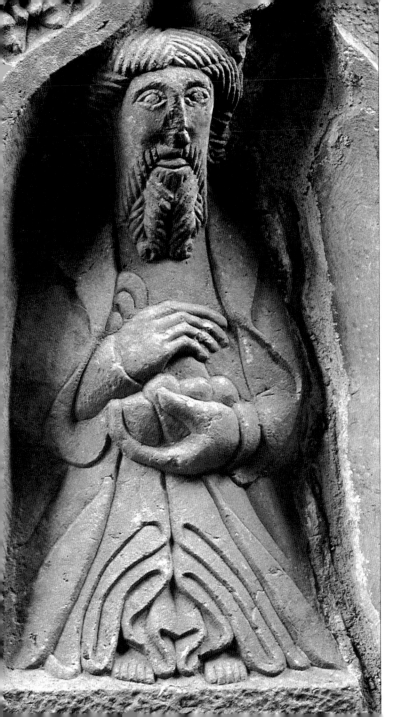

'WEEPERS', JERPOINT ABBEY, CO. KILKENNY

Left: THE CISTERCIAN ABBEY of Jerpoint was founded in the mid-12th century by Donal Mac Gillapatrick, King of Ossary. It was substantially rebuilt in the 15th century, and its chief glory lies not so much in its architecture as in its carvings. These include a fine series of statues in the cloister, along with some remarkable tomb-sculpture.

Shown here are three figures known as 'weepers', so-called because of their association with tombs. This particular tomb was executed by Rory O'Tunney, and features the Apostles St Thomas, St Bartholomew and St Philip. The first two carry the symbols of their martyrdom – a spear and a knife used for flaying skin – while Philip holds the loaves that he helped to distribute at the Feeding of the Five Thousand.

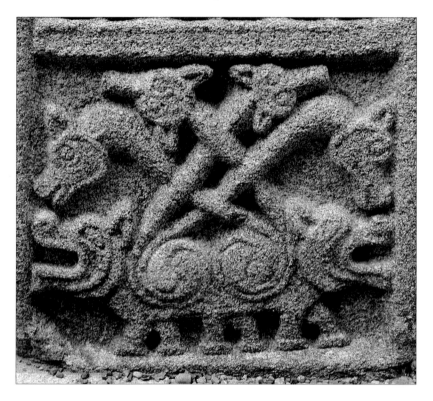

DETAIL FROM THE MOONE CROSS, CO. WATERFORD

Above: MOONE BELONGED to the Columban group of monasteries founded in the 6th century. Accordingly, its high cross was dedicated to the saint and some aspects of its decoration were inspired by Columban manuscripts. These intertwined creatures, for example, might easily have sprung from the pages of the *Book of Kells*. Two leonine beasts stand back-to-back, sharing a single pair of hind legs, while a series of serpentine monsters sprout from their flanks and attack them.

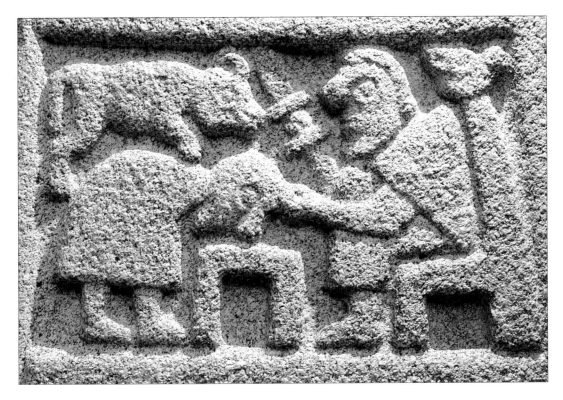

DETAIL FROM THE MOONE CROSS, CO. WATERFORD

Above: UNUSUALLY, THE CROSS at Moone was carved from granite, an unyielding material that forced certain economies of style upon the artist. As a result, the figures display a certain simplicity, with their squat bodies and childlike faces. Here, the Sacrifice of Isaac is depicted – Abraham raises the knife, as his son bends over the sacrificial altar. Above them is the ram, which will be eventually killed in Isaac's place. The theme was popular as it prefigured Christ's sacrifice at the Crucifixion.

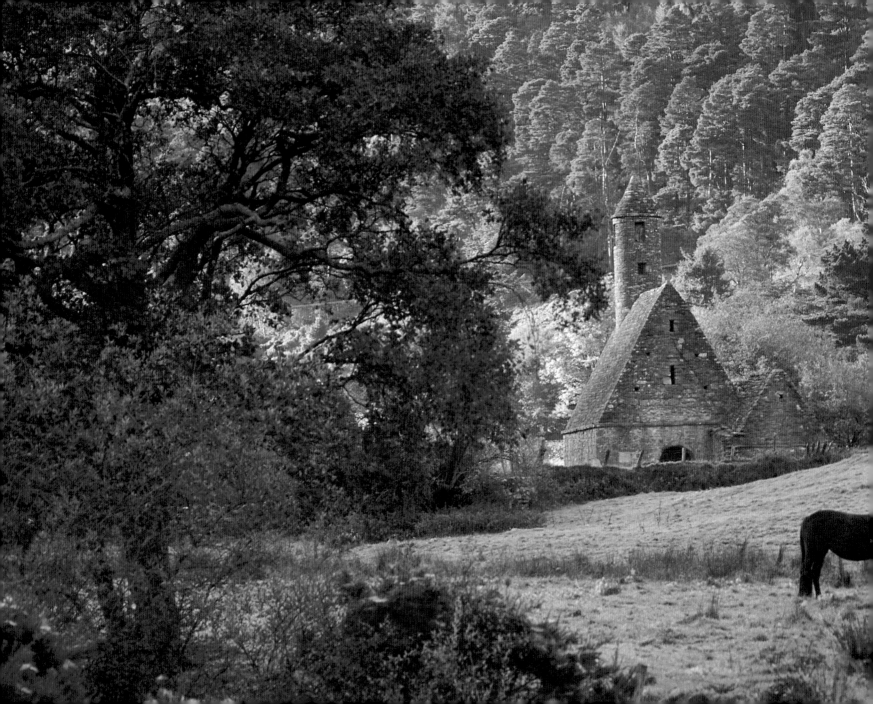

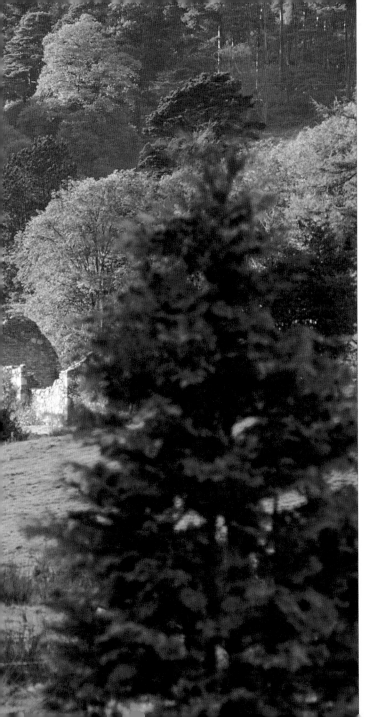

GLENDALOUGH, CO. WICKLOW

Left: THIS SPECTACULAR MONASTERY was founded in
the 6th century by St Kevin, a member of the ruling
Leinster dynasty, who chose instead to become a hermit.
His original retreat was in a barely accessible cave,
known today as St Kevin's Bed. As his fame increased,
other structures were added in a haphazard fashion. The
present jumble of buildings, which is more akin to a tiny
village than to the traditional idea of a monastery, offers
a telling picture of early monastic life. In keeping with
the beauty of the place, Kevin's miracles were closely
linked with nature. Once, when he was ill, an otter
brought him a salmon to eat in his cave. On another
occasion, so the legend goes, a blackbird laid an egg in
his outstretched hand. Not wishing to disturb it, the
saint stayed rooted to the spot until it hatched out.
These gentle tales may be misleading, however, for the
area was far from tranquil. As the lofty Round Tower
suggests, Glendalough was a popular target for Viking
raiders and was looted on at least four occasions.

BURIAL GROUND, GLENDALOUGH MONASTERY, CO. WICKLOW

Below: THE PRECINCTS OF THE monastery contain a wide scattering of early grave-slabs and crosses. Many of them are inscribed with the word '*oroit*', from the Latin 'to pray'. Not all of the graves belong to monks, for Glendalough also became the resting place of the local overlords, the Uí Dúnlainge. This honour was doubtless a reflection of St Kevin's fame. Even so, it is ironic that a monastery, which was deliberately located in a remote and isolated spot, should have effectively been used as a royal chapel.

ST KEVIN'S KITCHEN, GLENDALOUGH, CO. WICKLOW

Right: THIS STRANGE, ROMANESQUE building was probably designed as an oratory or a mortuary chapel. Its curious nickname may be due to its chimney-like turret. Alternatively, it may be a distant echo of ancient pagan traditions about a sacred hearth-flame. This was supposed to be a perpetual fire, which provided heat for all the other hearths in the community. Christian settlements were often built upon earlier sanctuaries, where the hearth-stone would be broken up and incorporated into the new structure.

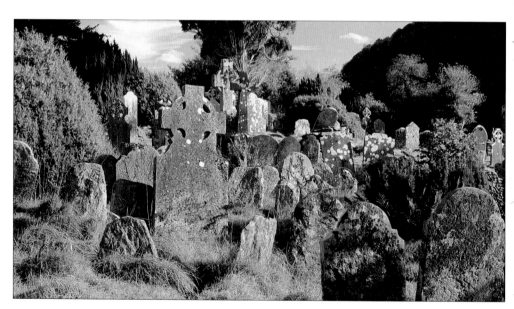

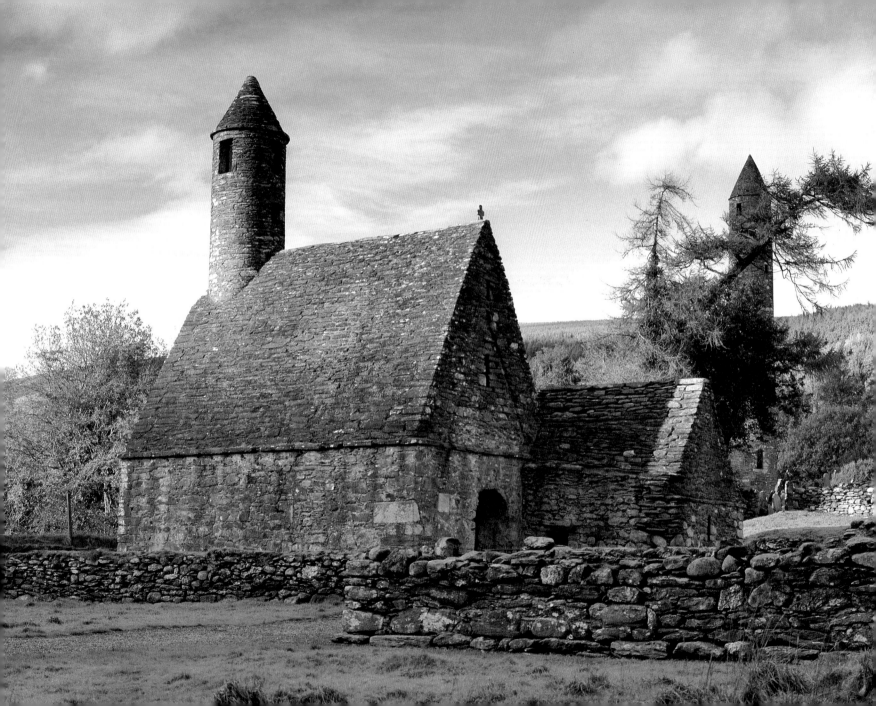

CASTLE OF JOHN DE GREY, CLONMACNOIS, CO. OFFALY

Right: ON A GRASSY MOUND near the banks of the river
Shannon, a cluster of stone fragments balance precariously, like
a row of tumbling dice. This is all that remains of the castle
erected in 1212 by John de Grey, the Bishop of Norwich. Its
construction dates from the period when King John
(1199–1216) was seeking to consolidate his power in Ireland.
Accordingly, in 1208, he appointed one of his most able
administrators as his Justiciar (chief representative). De Grey
had been John's nominee for the post of Archbishop of
Canterbury, and he soon demonstrated his efficiency by
building a series of powerful strongholds, most notably at
Athlone and Clonmacnois. The latter remained largely intact
until the 17th century, when it was destroyed by Cromwellians.

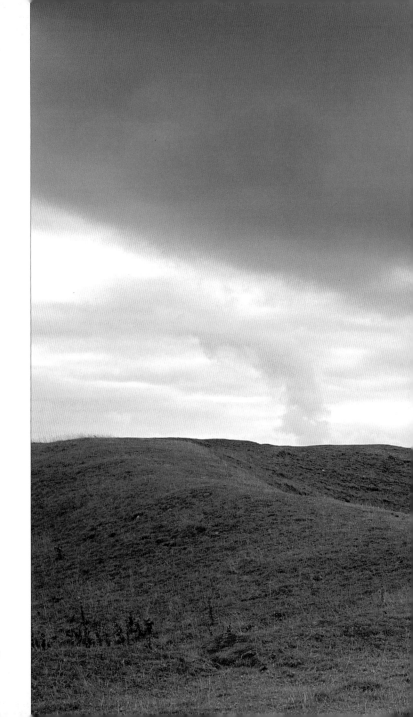

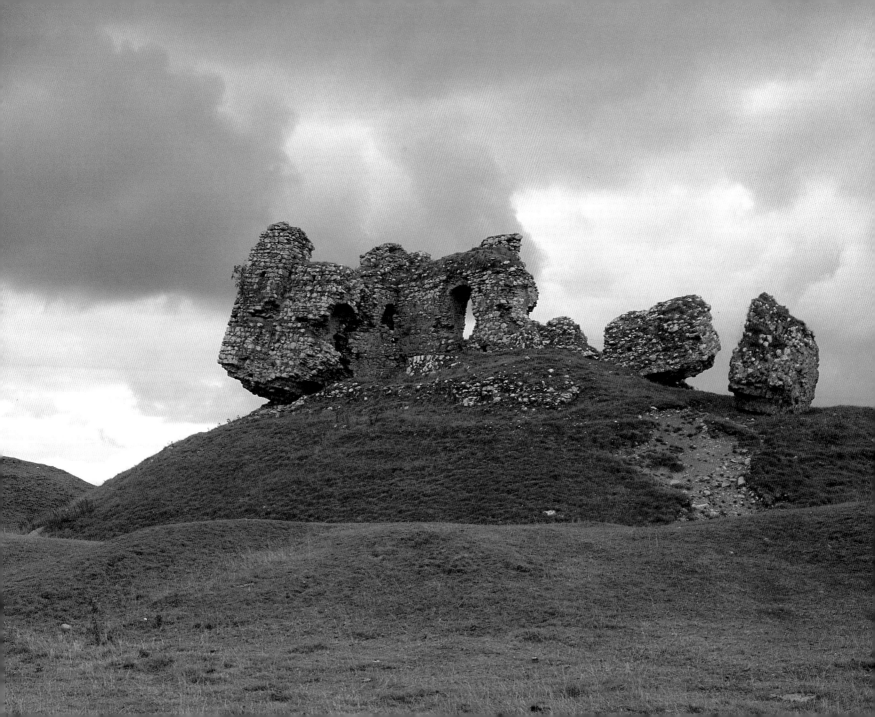

The Land of
Cú Chulainn

The Kingdom of
Connaught

The Middle
Kingdom

The Kingdom of
Leinster

The Kingdom of
Munster

Map of
Ancient
Ireland